HISTORIC HAUNTS AROUND DENVER

HISTORIC HAUNTS AROUND DENVER

KEVIN PHARRIS

Published by Haunted America
A Division of The History Press
Charleston, SC 29403
www.historypress.net

Copyright © 2012 by Kevin Pharris
All rights reserved

The cover image shows the original front entry for the Grant-Humphreys Mansion.

Images are courtesy of the author unless otherwise noted.

First published 2012

Manufactured in the United States

ISBN 978.1.60949.738.5

Library of Congress CIP data applied for.

Notice: The information in this book is true and complete to the best of our knowledge. It is offered without guarantee on the part of the author or The History Press. The author and The History Press disclaim all liability in connection with the use of this book.

All rights reserved. No part of this book may be reproduced or transmitted in any form whatsoever without prior written permission from the publisher except in the case of brief qotations embodied in critical articles and reviews.

This book is written to honor the memory of my mother. In losing her, I have lost one of the best parts of myself.

Anne always remembered the silvery, peaceful beauty and fragrant calm of that night. It was the last night before sorrow touched her life; and no life is ever quite the same again once that cold, sanctifying touch has been laid upon it.

—Anne of Green Gables

CONTENTS

Preface	9
Acknowledgements	13
Introduction	15
I. The Ghosts That Stalk Suburbia	19
II. Seeking the Things That Sound in Darkness	59
III. The Ghosts Through the Doorway	75
Bibliography	109
About the Author	111

PREFACE

I had decided that you were not going to be reading this book right now, but as is often the case with the ghostly things that seem to be my lot in life, the spooky side has intervened.

My name is Kevin Pharris, tour guide and owner of Denver History Tours. I am also the "accidental ghost hunter," and I do not like scary things. Yet I authored a book, *The Haunted Heart of Denver*, in the autumn of 2011. No one was more surprised than I was, you may be certain. Still, the accolades poured in, and folks began to bandy about the idea of my doing another haunted book. Allow me to share some of the innumerable plaudits I received:

> *Pharris' book turned me into a quivering pile of terror; I felt as if I should have the professor's name from that Pilkey book! I shall buy some more unmentionables and await the next treatise on all things ghostly!*

> *Never, in all the annals of history, has there been a book with 36,465 words. I felt awe and shall avidly count the days until the next tome arrives on my doorstep.*

> *Pharris uses "sesquipedalian" correctly and is not a pedant in so doing. He shall achieve great things, assuming he uses the word "crepuscular" in his next book.*

Ah, such laurels, such praise! Still, I was originally going to wait a year to write my next book owing to a busy schedule. On a springtime vacation, I came to that very conclusion. On my first day back from vacation, I boarded the mall shuttle in downtown Denver to give a tour. I had my megaphone with me so as to be heard over the traffic, sirens, bustle, hustle and general mayhem of downtown. As I sat down, a lady nearby looked at me and then at the megaphone.

There are a few fundamental truths in the world. You've heard about the one concerning the falling piece of jellied bread, of course. You are probably also aware that puppies are irresistible to people in almost every nation on earth (the Comoros being a notable exception, interestingly enough), but if you are not a tour guide, you likely do *not* know about megaphones. A megaphone hanging from my shoulder is one of the most compelling sights a person will ever see, judging from past experience—so compelling, in fact, that people feel they *must* talk to me about it.

I am a pretty average-looking guy (I know, I know, hard to believe), and when I walk down the street, no one gives me a second glance. Not so when I carry the megaphone. *Everyone* talks to me when I am carrying my megaphone. I mean, mine *is* enormous, but it's not beyond the scope of possibility. It's weird! So, this lady asks about the megaphone. I respond that I am giving a tour, and she murmurs something appreciative of history. Then, in the silence of strangers that is about to enfold us, I have an idea just pop right into my mind: "Ask her if she has any ghost stories."

Feeling slightly silly, I mention that I have authored a ghost book and am researching another one. Might she have any ghost stories of her own?

"Why, yes! The house I grew up in was extremely full of ghosts, and my whole family was aware of them!"

She proceeds to tell me about her home, her features animated by reminiscences both fond and chilling. As she is getting ready to get off the mall shuttle to head to work, I ask for her contact information. Eventually, I would tour the location where her childhood home formerly stood, but at that moment all I could do was emit a somewhat resigned sigh. Clearly I was meant to write this book right away, so here I am, and here you are immersed in these pages.

At this point, before you do anything else, you must ask yourself a question: have I read Kevin's first book, *The Haunted Heart of Denver*? If the answer is yes, well done! Your life is that much closer to completion, and you are ready to proceed without any delay. If the answer is no, you must rectify this oversight immediately. Please get to the bookstore or the library, and once

Preface

you have the book in your hot little hands, read it. Right now (or tomorrow, if you are reading this before bed). Don't read any more within this book until that preparatory task has been accomplished. I will patiently wait.

Seriously, I will still be here.

(This part is where those of you who have *not* yet read my first book pause to read it.)

See? Still here.

So, without any further delay, let us begin. To that end, a short history of Denver, the shining city of the High Plains!

Acknowledgements

Through numerous interviews, pictures and shared treks, the stories have really woven themselves. I would like to thank the people who have generously given me access to their homes, businesses, time and experiences so that I might create this book, especially to Maggie and Ivy, without whom this book could not have been written. Thanks for sharing! I also extend fervent gratitude to the folks at Active Minds who put out the call for folks with streetcar memories, and along the way I ended up with some ghostly tales, too. Finally, in the love department, I thank Sibadili Nia Kwa, ever supportive, ever my advocate, stalwart in so many things. *Ngam wanzo!*

Introduction

In certain instances in this book, the names of people who have experienced these events have been changed so as to protect their anonymity from the possibility of obtrusive ghost hunters. Historic names, however, have not been changed, nor have any addresses listed.

Founded in 1858, Denver City (as it was known in its earliest incarnation) was built on gold, a hunger for land, gold, wanderlust, gold and a dash of that good old let's-get-away-from-it-all spirit that was filling the hearts of many folks from "the States" as the nation rushed headlong into the terrors of the Civil War. Many people who felt out of luck after the Panic of 1857 found the prospects of a new start in the West quite appealing. Add a smidgeon of ignorance, a healthy portion of racism and an abundance of belief in Manifest Destiny and you will have some understanding of Denver in its earliest days. Though founded on high hopes of achieving preeminence over the other squatter settlements then popping up all over the place on lands promised by treaty to the Native Americans, Denver City's future was by no means secure. The next big gold strike and the get-rich-minded gold hunters would leave it to return to grass and dust. What the city needed were promoters who would turn it into something grand, something memorable and strong enough to withstand the trials to come.

Many rose to the challenge and made lasting marks on the city, working tenaciously right from the start. When Isabella Bird, author of *A*

Introduction

Lady's Life in the Rocky Mountains, wrote of Denver, she said it was "a great braggart city spread out, brown and treeless, upon the brown and treeless plain, which seemed to nourish nothing but wormwood and the Spanish bayonet." She had less complimentary things to say about Greeley, Fort Collins and almost everywhere else she went, but not everyone echoed her sentiments. The lure of gold drew many west with the "Pikes Peak or Bust" gold rush, begun as the 1850s drew to a close. Others would come once President Abraham Lincoln signed into law the Homestead Act, encouraging settlement and cultivation of western lands. Though Denver was a dangerous city for many, the Queen City of the Plains would outlive the naysayers, buoyed by the resolute efforts of countless Denverites. We will discuss some of these towering figures within the pages of this book.

Around Denver, other cities grew. The names of some neighborhoods, such as Valverde, Barnum, Globeville, Elyria, Highland and Highlands, reflect former cities that merged with Denver over the years. Other cities stand proudly separate to this day, such as Westminster and Littleton. Each has its own parade of powerful figures who promoted its march into the future. They dauntlessly built their cities to last the ages. Well, that's what they thought they were doing, at any rate.

After the 1940s, the United States embraced a new paradigm for its cities. Streetcars, Victorian buildings and downtown residential neighborhoods vanished in a chaotic orgy of demolition as Mr. and Mrs. Public drove their shiny new cars to their shiny new homes with carports, central heat and air and shiny chain-link fences. It was a boon for builders and those seeking the modern comforts of the 1950s, when "man had mastered the atom." So, too, it proved to be a catastrophe for Denver's historic structures, when whole neighborhoods fell to the wrecking ball. The tumultuous 1960s would almost be over before the idea of historic preservation could blossom in Denver enough for someone to stem the tide of annihilation.

The result of this indiscriminate destruction is the dearth of historic structures in Denver compared to the number that once stood. Nevertheless, some few buildings remain, and even where the buildings themselves are gone, the stories of those who lived and worked within them carry on to this day. Thus, it is not only the ghosts of people haunting Denver's memory; there are ghostly buildings, too, great edifices that once smote the eye with their opulence, now reduced to memory and long-forgotten rubble.

Introduction

Leaving behind the 1900s, Denver has achieved a fine balance between stalwart movement toward the future and respectful veneration of the past. Setting aside those glittering glimpses of the future, let us now examine the richness of Denver's history and the ghosts of buildings and people who now call history home.

I
The Ghosts That Stalk Suburbia

Having grown up a little of everywhere as a military brat, I am frequently befuddled by the attachment people feel to a place. I like Denver, don't misunderstand me, but I also like Pensacola, Chicago, St. Johnsbury and Bird City. Each would have something to offer me if I lived there. The depth of my oddness really came through to me when I was on a cruise in the beautiful Caribbean. We were sitting at a table, making the painful small talk that such events necessitate, and one of the questions that invariably came up for everyone was: "Well, where are you from?" One of the ladies at our table, when this question was directed at her, replied that she was from St. Charles, Missouri. "Oh! Where is that?" came the rejoinder. "It's just outside St. Louis."

Now, I've been to St. Charles, and it's a nice place, but I thought to myself, "Wouldn't it have been easier to reply that you were from the St. Louis metropolitan area in the first place and save the trouble? How inefficient!" It would be the same if she had replied she was from Arvada. Folks in St. Louis and environs are familiar with St. Charles, and folks in Denver and environs are familiar with Arvada, but outside a very limited geographic area, no one is going to know this person's little burb. All the same, I have witnessed it time and time again in my travels. Beyond showing that most folks are just not that interested in efficiency (something anathema to me, of course), it demonstrates a key element involved in this chapter. Most people who don't move as much as I did growing up are quite attached to the places they call home, however small or obscure or overshadowed they might be by larger, better-known neighbors.

Every city, whether large or small, has something to share, and in learning the spooky experiences from people's lives, I came to understand that ghosts don't limit themselves to downtown. Quite the contrary: ghosts may settle anyplace where lives have been led, emotions have been felt and people have died. This includes the entirety of the Denver metropolitan area, which is why we begin our tales today not along the corridors of history trodden by so many in Capitol Hill—and not even in Denver—but in Littleton.

The gold rush into our area brought a lot of people who were not simply intent on gold. Some were determined to make their mints other ways, and one of the most common was in land. Founding a city and having it named after you offers a bit of immortality, you should know. It worked for William Larimer, who founded Denver and placed his name on our main downtown street. As Denver grew, it rapidly became clear that the city needed water. The region was not the "Great American Desert," as was generally believed, but it was still quite dry. "Water," the cry rang out, "we need water!" Water was necessary for homes, businesses and farms. Larimer didn't stick around long enough to take care of the water issue—or plan out irrigation needs for cemeteries, for that matter—but others would take up the call that Larimer left unheeded. Without water, gold would not have sustained Denver for long.

A system of ditches was designed to provide this water to the burgeoning city. Among the people hired to create these ditches was a young gentleman named Richard Sullivan Little, from New Hampshire. While surveying the area south of Denver, he fell in love with a particular stretch of the South Platte River. After filing all the legal paperwork to obtain land and the right to a home, Little brought his wife out to see her new slice of heaven. The year was 1862, and his wife, Angeline, must surely have balked a little at what she saw. Sure, the view of the mountains was gorgeous, but anyone who thought it was civilization had been out in the sun too long. All the same, the Littles set to work with a will and, along with some neighbors, began turning their little section of the High Plains into what would become an agricultural powerhouse. They helped build the Rough and Ready Flour Mill in 1867, which not only helped them process their grain locally, rather than having it (and the funds associated with it) sent elsewhere, but also brought stability and investment to the area. The ditch Mr. Little had helped to create brought water to Denver, as well as to his own little part of the world.

With the arrival of the Denver and Rio Grande Railroad in 1871, the settlement began to boom. The Littles, deciding to go for the whole enchilada, mapped a village on their own property. As Colorado became the Centennial

The Ghosts That Stalk Suburbia

State in 1876, their successes were numerous. There were churches, schools, businesses and agricultural pursuits springing greenly from the sun-drenched ground. Incorporated in 1890, the city that bore Richard Little's name would eventually become the county seat, which brought more money (government workers, you know, used to drink a lot of liquor) and the continued rise of agriculture. Part of Littleton was once known, somewhat pejoratively, as Pickletown (owing to this agricultural foundation), and overall, the city has made some enormous changes to its landscape. The city moved the South Platte River a little farther west (yep, it moved a river) so it would not be right on the doorstep of downtown, and it even got a library from the Andrew Carnegie Foundation. The building would later serve as a jail, oddly enough. The city survived the disastrous flood on the South Platte River in 1965 (look for the buried train car at the Carson Nature Center—wow!). The city offers an original city hall (complete with a pressed tin roof in one courtroom), the Littleton Museum (home of not one but two 1800s homesteads) and the final resting place of noted epicurean Alfred Packer. (Just in case you don't know, Mr. Packer thought himself an accomplished guide. An expedition through

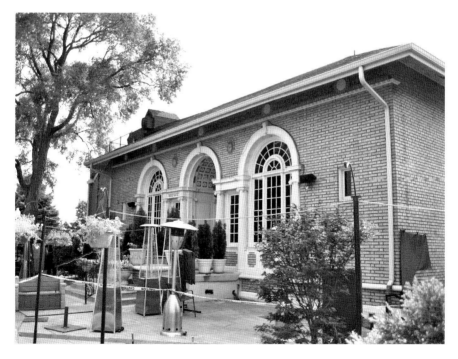

Once a Carnegie library, the Melting Pot now offers delicious meals with the option of a little ghost on the side.

western Colorado turned disastrous, and he was accused of killing and eating those who had hired him. Long story, but for now I think I'll take a break and get some ribs.) All in all, Littleton has a great deal to offer, including some astonishingly stunning and historic buildings and Alfred Packer's final resting place, where he's losing weight.

The Melting Pot restaurant sits in the heart of downtown Littleton. Its feature food is fondue. You and I are not the only type of people who hang out there, though. There are also a number of ghosts. Apparently, even ghosts have a nose for food. This would make sense, after all. The man who, in the opinion of some with a gruesome sense of humor, enjoyed the finest meal ever served in Hinsdale County came to his final resting place, as a vegetarian, in the city. Before I am run away by Alfred Packer jokes, however, let's get back to the Melting Pot.

Started out as a Carnegie library, check. Served as a prison, check. Is that it? Nope! The area has had its share of tragedy, with floods claiming a number of victims whose bodies were never found. Employees hear voices from rooms where no guests or other staff members are to be seen. Since the building used to be a place for carrion and Madame Librarian, staff members hear the roll of ladders moving among long-gone stacks of books. The doors leading to the back of the building have shaken powerfully—heavy doors that would take great strength to budge, moving backward and forward as effortlessly as if they were being tossed about by a child, even as the staff members watched the event in person and on security cameras. They saw no one there. Waiters and waitresses don't like to work the tables in the locations that used to be the maximum-security cells, reporting frequent cold and a feeling of malevolent hatred. One wonders if these people tip poorly as well. Objects have been thrown around, even some weighing twice as much as a person. Don't worry: patrons at the restaurant have generally been left alone. So, if you are looking for a meal with a side dish of zesty spooks, the Melting Pot in downtown Littleton is the place for you. You may choose to eat so much that folks will accuse you of "packering" it in.

Yikes, did I just say that?

Now, we're off to the city of Westminster.

At this point, I know what you are saying.

"Kevin, I am *loving* the book so far. Really, how do you do it? [It does boggle the mind, I admit.] All the same, I am a little confused. We were in Denver, then we were in Littleton and now we're going to Westminster. Are we playing haunted hopscotch here or something?"

Well, no, though that does sound like a lot of fun.

The Ghosts That Stalk Suburbia

As I have cast my ghostly net wider, ever wider, I have found (as I mentioned before) that not all ghosts are located in the downtown core of Denver, even though the city is dynamic, interesting and full of extremely good-looking tour guides. With the stories arriving on my doorstep (so to speak) from so many different places, it necessitates a little jumping around geographically. Just keep your eyes focused on the page and you will not get vertigo, dizziness or anything else as we zip around the metropolitan area. Anyway, consider yourself lucky. Just wait till I do my books on the state of Colorado as a whole: Colorado Springs, Durango, Hayden! You'll be in so many places, your head will spin (not literally, as in that movie). For now, however, let's make our way to the wonderful and welcoming city of Westminster.

Westminster is part of the sprawling city nestled by the mountains that, as folks fly overhead as they travel from coast to coast, the captain of the plane might identify as Denver. Indeed, for those driving through the metropolitan area, there is little to indicate that one has passed out of Denver and into any of the myriad cities that surround the giant at the core. All the same, these cities have unique histories all their own and much to share. Westminster (or, as it is frequently stated in a verbal tick common to the inhabitants of the city, "Westminister") was home to bison, antelope, sagebrush and numerous marshes and ponds before it began its move toward urbanization. The first permanent resident bore the name Pleasant DeSpain and settled his farmland in 1870. Others followed, locating in the area known then as DeSpain Junction. One was Edward Bruce Bowles, whom we will discuss a little later. The little grouping of homes and farms around DeSpain Junction grew into a flourishing farming community. With the arrival of the railroad in 1881, things became easier, but the arid climate proved a consistent impediment for many would-be toilers of the land. Many sold their lots to C.J. Harris, another fellow we will discuss in a bit. Steadily building up the community, he rechristened the area Harris (he thought highly of himself, clearly), with DeSpain's blessing. Eventually, the city would attract institutions meant to elevate the whole area, including a Presbyterian school that, according to one of the donors, must be modeled after Princeton University. It was called the Westminster University of Colorado, and it was not long before the area bore the same name as well. In 1911, Harris incorporated as a city, changing its name to reflect the prominent red sandstone structure on the hill. The city of Westminster was born!

With such a diverse background and rich history, it makes sense that the city's ghosts should be equally diverse. So we dive into the other side of Westminster, where ghosts admire art, guard their dirty little secrets and make sure work is done well.

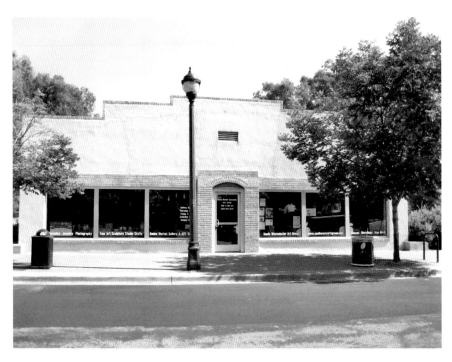

A building need not be grand or historic to attract ghosts. Sometimes they are drawn by art, as well as the people within, because even ghosts like to browse.

Located at 3915 West Seventy-third Avenue, the Rodeo is ready for any art critic, even those critiquing from the other side.

The Ghosts That Stalk Suburbia

Our first ghost rendezvous in Westminster will be the Rodeo Market Community Arts Center at 3915 West Seventy-third Avenue. This was also the first Westminster ghost venue I came upon during my explorations of the city, so starting with it now is quite symmetrical. Within the stucco-covered walls of the gallery, I met Carol C., a three on the psychic scale (which is the highest level of awareness, as you know), who has not only had a lifetime in association with ghosts but also gets the fun of their presence in her work life. As with Ivy, whom I interviewed for *The Haunted Heart of Denver*, Carol's visitations by the spooky set began when she was young:

> *I grew up in Boulder and would see ghosts as early as when I was three years old. They would talk to me, and I was not afraid. One man asked for my grandmother. He had a strange accent. He would say, "Where's Anna?" I would go and tell my grandmother that someone was upstairs asking for her. She would freak out because no one called her Anna anymore. That was a name that they had used back in the old country, before they immigrated to the United States. We all knew her as Katerina. She never saw what I had seen, and the ghost never stuck around long enough for me to show him to her, but he came many times looking for her. I was only three, but she let me know that it was just a friend from the old country looking her up, and I should not be afraid.*

It was during her youth in Boulder that a ghost, named Jack, attached to her:

> *I hear him sometimes. He followed me as I grew up, moving from place to place. From Boulder, we moved to Broomfield and now here, and he has come along every step of the way. He is not allowed in the house anymore because, once I got married, he did not like my husband. He would get kind of aggressive with my husband and even pushed him once, so I told Jack he had to stay outside; he was no longer allowed in the house.*

We could wish that all ghosts were so obedient! Though they had been dating for a while, Carol felt it necessary to tell her husband about her spectral connections before they got married rather than springing such news on him after the deal was done. To his credit, he took the news stoically enough. The ghosts made their presence known to Frank, her husband, within the first few weeks of their marriage—rapping on the headboard of the bed while they were getting ready for sleep and moving the furniture. The ghosts have not always been so nice to Frank, but in interviewing him,

he reported making his way with fair equanimity: "I think part of the time with all their pushing, knocking and even the one ghost that smothered me a little in my bed, they are just trying to get me to believe in them, go easier on Carol. They really take care of her."

Attached to her bloodline long before Carol was born, it was one ghost in particular that turned her on to the world of art:

> *William has been around ever since I was a little kid. He encouraged me in art, writing, everything. My teachers didn't like it, my confidence in my work, but William said I should not listen to them and their detractions. I see him, I hear him, a guy in his seventies with a British accent. When he talks to me, I am just able to let myself open up, let the art flow through me. It's as if I am the pen, almost, and someone else is doing the writing or moving the paintbrush. The muse of art just takes over. When I see William and other ghosts, it's usually in mirrors, but not always. I usually hear from William, hear his voice, nothing more.*

Far from being simply a passive vessel for art to pour through, she has tried to initiate the connection, pushing through toward the source of these gifts and inspirations. There's a whole world of possibility out there that may be expressed in her art, so she sometimes strives to contact the ghosts around her rather than waiting for them:

> *I have tried to speak to those who've died, ask them how they are, if they have any messages for the living. It's worked, sometimes, but other times I get stopped. There's a guardian at the door between our world and theirs. He lets me get in sometimes, other times not at all. I think many people would believe that he is the Grim Reaper, but I don't see a ghost with a hood and scythe or anything like that. It's more the feeling of a really strong presence, a voice and a touch. Once, when I had made my way through the door to talk to the ghosts around me, he stepped in and told me that I did not belong there.*

The movement through that doorway of death is supposed to happen just the one way, when a person dies, so Carol thought it might be uncomfortable for this presence to let people with psychic gifts through the doorway separating the world of lives and the interims expressed in death: "He actually poked me with his finger once, and it did feel like bone. Sometimes I would get to speak with the ghosts a while, but he'd cut it short after a little bit. He said, 'Sometimes people have to die to respect life.'"

The Ghosts That Stalk Suburbia

Perhaps death makes you a little more appreciative the next time you come around for a go.

Interactive ghosts do not limit themselves to protecting Carol and occasionally getting physical with her husband. The world of art and the creative energies that surround it are as appealing to some ghosts as Carol's psychic presence itself. The gallery where she works, filled with an eclectic mix of artistic expression, from cast iron to paintings and more, is a stopping-over place for some ghosts making their way through the spectral highways and byways of Westminster. On a number of occasions, the ghosts have paused to admire the art, stopping in to browse just as the beautiful neighborhood's fleshy clients do:

> *I remember one instance in particular. The front door opened, and a little woman in a lavender dress came in, looking as solid as anyone. I said something or other, and she smiled, saying she wanted to look around, and she did. I watched her a little, moving here and there, and then she was gone, just not there at all. This place is full of all kinds of energy, not just art.*

Filled with vigor that is artistic as well as metaphysical, ghosts stopping by not only get an eyeful of loveliness, but they also have the chance to fill up on fuel, as one would at a gas station. How's that for ghostly convenience? I hope you will take a moment to visit the Rodeo Market Community Arts Center in Westminster. Frankly put, it has a lot to offer. Just remember to keep your eyes open—your third eye, too.

Now, let's move down the street a little bit and visit a splendid and historic home, the Bowles House, at 3924 West Seventy-second Avenue in Westminster. We mentioned Mr. Edward Bruce Bowles a little earlier. Having come to Colorado Territory from Missouri, Mr. Bowles and his wife acquired land through the Homestead Act, a location north of Clear Creek and south of Crown Point where a Presbyterian education facility would one day rise. At that point, Arapahoe Indians still camped on the promontory, and Mr. DeSpain, the first settler in the area, was himself a recent arrival. Construction of their two-story home was completed in 1876, the same year Colorado achieved statehood. The house was small by some standards but included a number of fine decorative elements. Outside, they planted orchards and tilled the soil for other crops. Edward Bowles worked tirelessly to bring the railroad through the area and lived long enough to see the success of his efforts, as well as raise nine children in the house before his death in 1923. Many people would have visited the

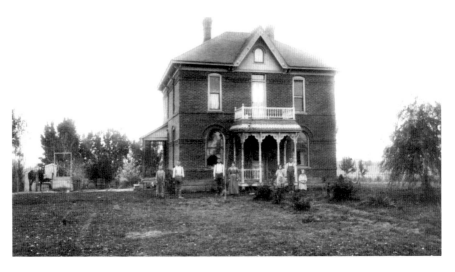

The historic Bowles House in Westminster has played host to many from as far back as when the city was small and the roads were dirt. *Courtesy of the Westminster Historical Society.*

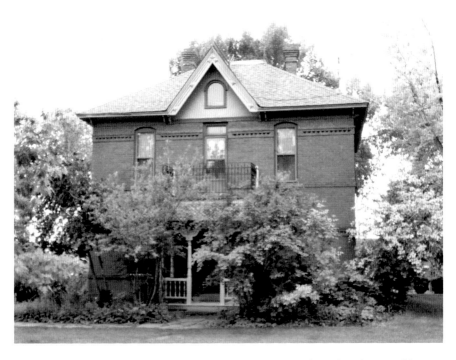

Today, the Bowles House Museum still entertains many guests, from those interested in history to those who leave their graves to sit down for a little kibitzing.

home, a haven for enjoyment and socialization, as the city of Westminster prospered and grew.

Unfortunately, the place was in for some hard times. After the house passed out of the hands of the family, it fell into disrepair. Its future was tenuous. Efforts to raise money for the purchase of the house by the city met with failures for many years. The fire department even planned on using the structure as a test burn. Finally, through a change in public appreciation of historic preservation and the tenacity of a group of students from Vista Grande Elementary School, the funds were raised, and the house became part of the Westminster Parks and Recreation System. Now completely restored, the Bowles House has been leased to the Westminster Historical Society (for one-dollar rent!) to create a museum within the historic edifice. Westminster, as with many cities, has lost much of its original history to innumerable factors, so having the house today is a fantastic and rare gift for those of us who live with and for history.

As it turns out, it is also something of a boon for those of you who live for those sometimes noisy, sometimes talkative, sometimes interior decorator–minded folks known as ghosts.

In working on this book, I had the good fortune to be able to interview one of the members of the staff at the Bowles House, Linda C. She graciously met with me to share her experiences, as well as those of others, and she allowed me to see the place for myself. I am happy to report that the ghosts did not show up for me during my time there. Maybe it is because I had my eyes closed the whole time. Well, most of the time. I did peek a little bit. Linda told me:

> *The house needed some work done before we could open it to the public, which took place in May 1988. There was lots of excitement in the community, and in the house, too, with the ghosts. I didn't really know the place was haunted back then, but I know it now. We had a workroom upstairs for the docents. I was here on the opening weekend all by myself, doing stuff upstairs, and I heard ladies downstairs, kind of twittering. It was the voices, the light laughter of a group of women together, that sort of thing. I thought a group of ladies had come into the museum, so I went downstairs expecting a large crowd. No, no one was there. I went back upstairs, not really thinking anything about it, and I heard it again. It was as if they were having a little social event downstairs, all chatting and happy, and I could hear it as plain as anything while I was upstairs, but not when I went down to look and listen. Other people staffing the building*

would have the same thing happen to them, always when they were upstairs and no one was on the ground floor. This area, the room we hear the sound from, used to be set up as a sewing room, so it would have had lots of ladies in it sometimes. It sounds as if they are still here!

Workers preparing the building for its opening encountered problems as well and shared their feelings with Linda:

We were having some problems with our telephones, so this man came from the phone company to work on them. I heard him in the basement. Moving ladders or boxes or something like that I would have expected, but I heard him singing "You Are My Sunshine," which I thought was a little unusual. When he came back upstairs, I asked him if he liked that song. "Not really, but the ghosts down there do. Did you know that this place is haunted?" I told him we were initially trying to downplay that part of the house's offerings, wanting to be seen more for history and such. It did not make a difference to the ghosts what our intentions were; they showed up for lots of people, and sometimes they were not nice chattering voices. That telephone man said he would not be coming back to work on the house, and he was not the only one to say that.

While a worker was putting in the building's security system, which required him to move throughout the extent of the place, he came to Linda after working a few minutes in the basement. He looked ashen, clearly shaken by something that had happened to him. He told Linda that there were people trapped in the walls and that they were asking to be let out, begging to be released:

He said they were very old people, with frail voices, but the pleading was very clear. He said he thought they had been trapped inside a chimney. When I told him that there had never been chimneys in the basement, he kept insisting that someone had been trapped in there all the same. They were imprisoned. Since he was finished in the basement, he went on upstairs to put in the motion detectors. A few minutes later, he came back down, looking sick. He had seen something more.

He reported that one of the upper rooms was full of ghosts staring at him, glaring and daring him to enter. He told Linda he would not be going in there. Linda sympathized but was getting exasperated by this point. If the

room did not have a motion detector, someone could break into the building through that room. He told her there were motion detectors in other parts of the upper level, so if anyone came in any other way, that person would set off the alarm. Whatever the conclusion, he was not going to be going into the room with all the ghosts, so his work was done. With that, Linda had to be satisfied.

Other workers have had issues within the house. At one point, while some workers were installing carpeting in the office on the main floor, Linda found that they had all moved outside onto the lawn to have their lunches. Since the day was not a particularly pleasant one, she went out to tell them that they would be welcome to eat inside if they chose. The workers paused, glancing at each other as if trying to determine how much to say. Finally, one of them told her that they wanted to spend as little time in the house as possible owing to all of the ghosts that were moving through the rooms. Linda said:

> *When we had our grand opening of the building, I invited all the workers who had helped restore the place to come and see the finished home. The fellows who had been doing the carpeting not only declined the invitation, but they also asked me not to contact them again for any work in the Bowles House.*

The ghosts in the Bowles House do not seem to have a problem with the general public, and Linda has had no reports that have come from folks visiting the house as guests. This benign acceptance of guests clearly does not extend to members of the working class. One wonders if the ghosts within the Bowles House are conscious, even in death, of a class division between themselves and some who come into their demesne. Linda continued:

> *We have lots of school groups come to the house as well, and scouts, too. Children have reported seeing ghosts in the upstairs rooms, the eyes in the pictures moving, watching them. The scouts who slept out on the lawn overnight and used the bathroom inside had to have their scoutmaster offer them some comfort on the subject. He said the ghosts would not hurt them as long as they behaved themselves in the house.*

Knowing that kids are sometimes destructive and fractious, the ghosts keep a watchful eye over them while they are within the building but do nothing more. Oddly, the ghosts seem to save their interactive energies for adults.

As for Linda and her own personal experiences with the Bowles House, where she has long offered her insight and efforts on behalf of Westminster's fascinating history, the most disquieting experiences were yet to come:

> *I have been involved with this house for a long time and am even the person the security company calls if there's ever a problem. That part of town is really very quiet, so I was surprised to get a call from them in the early morning hours one night. Something was happening at the Bowles House. The alarm had gone off. They didn't have any visual reconnaissance of what was happening, but the audio was working, so they let me listen to it. It sounded as if the whole house was breaking apart. I could hear shattering glass and big booms like splintering wood. It sounded as if the entire place was just crashing to the ground. In a panic, I got over there as fast as I could, expecting to find a pile of rubble. Nothing was wrong; no windows were open, nothing broken in any way. The only thing weird was one of the pictures had been removed from the wall and set on the ground.*

Though the Bowles House had been open for a while, it was a place of continual change, with updates, modifications, improvements and all the normal things that are part of the life of any active museum. The staff had recently put some new art, just framed, in the dining room. Although none of the other paintings had been moved in any way, one of them had been deftly removed from its hook. Linda found it leaning against the wall in the dining room. The glass was not broken, nor was the cord that had held it in place. The hook above was not bent, which meant that someone would have had to have lifted the painting so as to keep hook and cord intact before placing it on the floor. Had it dropped, the glass would likely have broken. Other than the painting being on the floor, Linda could find nothing else amiss. Bemused, she replaced the painting on its hook and went home. She recalled:

> *We talked about it the next day, the other members of the staff and I, and we thought maybe a train had gone by, making all the noise. We called the train company. They had not had any train going by the house when the alarm went off, so we thought it must have been one of the resident ghosts. A really loud ghost, I would have to say. The very next night, I got another call. Again the sound was horrible, almost like an earthquake, the breaking glass, wood splintering and exploding, everything. I went over to the house again in the dark morning. Everything looked OK that time, too, except*

The Ghosts That Stalk Suburbia

when I got to the dining room. The same picture had been lifted up and placed down on the ground, without breaking anything.

Though the whole episode was disconcerting, Linda and her colleagues concluded that there was something funny in the incident as well. Clearly, the ghosts had no approbation to give the painting in question. Rather than have continual nighttime jaunts to a house museum that was spiritually collapsing, Linda and her colleagues decided to remove the offending piece of art completely. Since then, the house has suffered no metaphysical earthquakes, much to everyone's relief:

This house really is a treasure for Westminster. It has so much history, so many stories. We find it funny, though, that the first questions we get from our school groups are always whether or not the place is haunted and how many people we have had die here. I guess it is safe to say that the Bowles House has a little something for everyone.

I think Linda's general sentiments are correct, though it may be doubted whether or not the ghosts are entirely welcoming to members of the working class. Blue-collar bearers, beware! Further, the ghosts are clearly discerning when it comes to art. So if any of you are artists seeking to sell your creations to the Westminster Historical Society, they had better be good or you might bring the whole Bowles House down around Linda's ears!

Moving on now, we come to a picturesque and historic section of the city, along streets that today bear names quite different from what they once were. Though Westminster would conform to the Denver street-naming system eventually (and rightly so, for when it comes to roads, conformity makes everything better), the streets bore different names in their earliest iterations. Seventy-second Avenue, a major thoroughfare for the city today, was once Wyoming Street. Seventy-third Avenue was Walnut Street, and Seventy-sixth Avenue was named by Pleasant DeSpain himself as Kentucky, for the state of his origin. Other names—St. Vrain, Maple, Virginia, High and Cornell—are now gone as well (though, oddly enough, they are often located elsewhere in the metropolitan area), but one name remains, and that is Bradburn Boulevard. Keeping with the Denver street grid, this scenic and historic drive should really be called Perry Street, but the change of name honors Donald Bradburn, the first Westminster resident killed in World War I. Long before Mr. Bradburn reached his sad demise, the history of one home along the street that would eventually bear his name was being set into motion.

Mr. Charles Harris, usually known as C.J., and his wife, Florence, moved into the Westminster area in 1885. His eyes were set on land speculation, for it was rumored that a university would soon be going into the area. Florence's eyes were set on raising the family. Using his wife's money, he bought land and constructed a charming three-story home at today's 7996 Bradburn Boulevard, a road that was known as Connecticut at the time. In order to increase the worth of the land he owned and encourage settlement, he had the maple trees that lined Connecticut Street planted. C.J. was going to make it big, though his methods were somewhat questionable, as was his manner of honoring his wife. He was frequently gone on business trips and spent much of his time in downtown Denver, leaving his wife and children in this still relatively sparsely populated section of the metropolitan area. Further, he spent his wife's money without her consent or knowledge in order to fund his schemes.

Florence, a very capable woman, eventually realized that she did not need her husband much after all, since she ran the house and homestead in his continual absence. She kicked him to the curb and raised the children on her own. Though C.J. succeeded in having the city named after himself during his time there, the name would fade into history in the long run, just as he faded away from home, wife, children and, eventually, Colorado altogether. That being said, C.J. was at least around long enough to construct this beautiful home. It had a number of fires, one of which destroyed the third floor, in 1928. The house would be remodeled with two stories only, which brings us up to the modern day and the ghostly encounters of the people who now call 7996 Bradburn Boulevard home.

Pat lives in the house with her son, Bill, and her son's wife, Debbie. I met Debbie first because she joined me on a haunted walking tour of LoDo, in downtown Denver. During our tour, she mentioned the issues she and her family have had in their home. You might imagine my reaction. It went something like this:

Kevin: You live in a haunted house in Westminster?

Debbie: Why, yes! My family and I could show you around if you would like to come up sometime.

Kevin: [Blink, blink, blink.] OK!

So, one day I rode the bus from downtown Denver to the Westminster area and got off along Seventy-second Avenue, then headed north along the tree-lined charm and beauty of the street that was my goal. Now, I am a skeptic and a registered scaredy-cat, as you know. No really, I have a membership card in my wallet. So, as I made my way up Bradburn Boulevard, my senses

The Ghosts That Stalk Suburbia

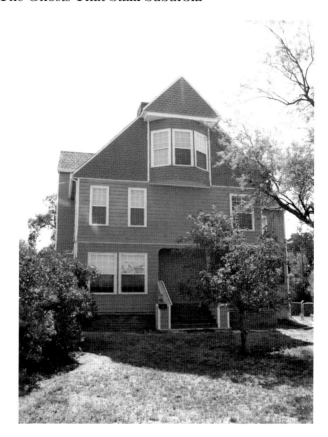

Florence Harris is still within the walls of her historic home, making sure everything is done according to her attentive eye.

were on high alert because I was going to a haunted house, something that I never relish. I looked around for hatchet murderers, zombies, malevolent dolls, clowns and aggressive panhandlers…all the normal things that haunt my dreams for months after doing haunted research. I saw none of these things (whew!), but I *did* see something else that intrigued me. Ahead of me, loping along the sidewalk, was a rangy little fox. Foxes move differently, not in the same way dogs do, so I was quite certain of what I was seeing. My beady little eyes tracked the beast, and I noted it pull into a yard on the west side of the street. I kept the place fixed in my vision, and as I drew abreast of it, I looked into the yard. I laughed to see a wooden porch with two really fat cats lounging there. On the actual front stoop of the house were a bowl of food and another one full of water. One presumes these were set out for the cats, neither of which seemed inclined to dine at the moment. Neither cat seemed alarmed by the presence of the fox, and the fox, for its part, seemed entirely uninterested in the cats. Indeed, it had found much easier prey: the

kibble in the bowl! Yep, it was greedily wolfing down (should that be foxing down?) the cats' food. Smart fox. It then ambled over to the water bowl and had a leisurely drink, all the while not exciting a tail twitch from the kitties.

Amused by this spectacle of the savagery of the animal kingdom in action—very sedate action—I then turned to continue on my way. My time with the fox was not done, however. It noticed my movement and trotted off to the north, the direction in which I was going. As I continued up the block, it paced me about a quarter of a block ahead. If the distance between us grew, it would pause and look back at me. Once I got a little closer, it would continue north along the block. In this fashion—a continual series of move, pause, check Kevin's progress, move, pause, check Kevin's progress—it led me right up to 7996 Bradburn Boulevard. As I drew up to the house, the fox gave me a look and then trundled off into the underbrush. Now, to be fair, Highway 36 is just north of the house in question, so the fox would have *had* to have turned one way or the other, but I still felt as if the fox had guided me right up to the home I needed. I like foxes, so it felt like a good omen, especially when you consider that nothing like this has ever happened to me in my whole life.

Knock knock went I, and Debbie showed me into her home. I met her mother-in-law and husband, and we sat down to dinner (they fed me!) and began the journey through the home's spectral commotion.

When the family moved into the home in the year 2000, there were only two stories to the place. It was a home in need of some love, so they had to make do with what they had even as they began working on it. Bill and Debbie lived upstairs (being a married couple, after all), and Pat lived downstairs. She was living alone at least during the daytime. At night, Pat realized that the place was not as empty as she thought:

> *Lots of times I would wake up and hear people talking. I would hear music playing as well, music from the 1940s. At first I thought I was dreaming, but I would get up and look around, so I was not dreaming. I could never find the voices or music, but they came back a lot. I didn't really mind it, but all the same, I would tell the ghosts that it was OK for them to go, just move along. We even had a psychic come and bless the house. After a while I didn't hear the voices anymore. I think they thought we were going to tear the house down, but when they saw that we were* not *going to be doing that, they relaxed.*

Though the family was not going to tear the house down, there were huge changes in store for the structure itself. It soon became clear that living in

the house at the same time the house was being restored was not going to be a huge hit with anyone (the ghosts among them), so the family moved out in 2004. The house was stripped down to its bare bones, with every original furnishing lovingly restored and held in reserve for eventual placement within the confines of the historic home. Bill—whose natural skills in construction were complemented by his willingness to learn about any skill set in which he had no experience—would begin one project only to have things go awry with his direction of choice:

> *Even though we would intend to go in a particular direction, things would happen within the house to show us there were other things we needed to do first. We didn't know about the fire damage in one area or the fact that the supports in another area didn't even reach the ground. We would begin a project and things would go wrong, drawing our attention to things that needed to be done first. It was as if the ghosts in the house, aware that we were trying to bring the place back, were pointing out the correct order, showing us things that would cause problems later if we didn't do them in the right series. It was frustrating, but in the end the house is better off for the ghosts getting in our way!*

Though causing things to break, misplacing tools and undoing previously finished work might not sound entirely helpful, the ghosts sometimes showed their benevolent natures in less physical means. While restoring the stairwell between the first and second stories, Debbie and Bill realized that many of the original balusters were missing. One night, one of the ghosts led Pat, in a dream, to a section of wall. There was no reason to believe the wall was any different from any other, but the implication was clear: there was something significant within the wall. In the morning, Pat acted on the strength of her dream and took a crowbar to the wall. Within it, lodged between the wooden framing and under the sheetrock, were the missing balusters. They had been stacked there by some unknown person and then covered up, forgotten for decades behind walls that gave no hint as to their presence. Bill replaced the balusters in their original position, and no doubt the ghosts were pleased.

Pat, who experienced the dream, could recollect its intensity. The ghosts of the home had helped her learn a secret, one of many the house would eventually disgorge. The ghosts monitored the progress of the family's efforts at every step and could even be seen doing so on occasion. Pat, the photographic chronicler of everyone's toil, explained, "I took pictures of everything we did. Sometimes we could see figures outside the windows,

looking in at us as we worked. No one was really there, but we could see them in the pictures."

Sometimes the ghosts expressed themselves rather forcefully, and the family was not always clear about what was being said. Perhaps the ghosts were just venting emotion as the house came down in order to make its way back up again. During a party before they left the house in 2004, with everyone assembled in the main dining room or nearby, the heavy metal fireplace cover shot across the room with a terrific clang for no apparent reason, startling everyone. Laughing, Bill summed up the reaction:

> *No one could explain it, even those of us who worked construction all the time. That metal fireplace guard is heavy, original to the house and takes a lot of effort to move, yet it flew across the room like nothing. The party was done then. Everyone went home.*

Apparently, ghosts are the answer if you ever have guests you want to get rid of really fast! Another secret would be uncovered when the family pulled up the floorboards in one of the main-floor rooms. Within an alcove under

First picture in a set of four, taken as the family was about to uncover a long-hidden secret within their home. *Photo courtesy of Debbie T.*

The Ghosts That Stalk Suburbia

Taken a fraction of a second after the previous image, it is clear that someone wants certain secrets left undiscovered. *Photo courtesy of Debbie T.*

Stronger still, the ghost was unable to prevent its liquid history from being unearthed by the family. *Photo courtesy of Debbie T.*

The ghost vanished a moment later after venting its displeasure, though the family would not know it until the pictures were developed. *Photo courtesy of Debbie T.*

the boards, a space about three feet long by two feet wide, they found a cache of liquor bottles, many of them broken and all of them dusty and dating from the later decades of the 1800s. This discovery gave rise to a lot of excitement, as did a series of pictures Pat took in rapid succession as the recessed area under the insulation was about to be uncovered. Though taken seconds apart, the pictures clearly show something present. In their discovery of the secret space, as well as the pictures, the family's conclusion was that some ghost did not want its liquor habit of long ago revealed, even after death.

Debbie, who has spent a great deal of time looking into the other inhabitants of the house, as well as their original history, explained the progression of encounters within the house as simply a matter of ghostly pride:

> *C.J. built the place using his wife's money, using cedar shake and designs that do fine on the East Coast but not so well here, then practically abandons his wife to raise their kids in the middle of nowhere all on her own. Florence was a tough woman, very strong. She divorced him and kept right on going, never losing steam. She did everything. It was her work, her money. The*

more I looked into the history of the house, the more I realized that we had things wrong. We always referred to the house as C.J. Harris' place, C.J. this, C.J. that, when he really did nothing to speak of at all. I had the feeling that Florence was angry at this injustice, so we began to change our wording. We began to refer to it as Florence's house, Florence this and Florence that. The feeling of the place, the things we would see, the almost temperamental damage that would take place to things we had already done just stopped. I think we got it right, and she was glad.

The family moved back into the home in 2010, having accomplished much. They continued to see people in the windows, watching them work from the outside. The reverse was also true. On a number of occasions, while congregating or working in the yard and driveway, they would see the figure of a woman in the window, watching them from within the house, even though they knew that the house had no people within it. Florence was keeping a critical eye on everything they were doing.

The touch of something beyond the everyday has been part of the family's association with the house from the very start, as Bill explained:

This place had so many things beneath the surface. There were a lot of secrets, and bringing it back to its original glory has been something of an obsession for me. Not easy, not cheap, but we have just done it a bit [at] a time, always moving forward. Even the way I came to learn about the house was really odd. I was a single guy at the time, looking for something to work on, something to make a project for myself. I was flying to Chicago, and this lady sitting next to me just starts talking to me out of the blue, telling me her whole life story. Next thing, she's talking about this house she wants to sell, a historic house. As soon as I heard her talk about it, I just knew that this was the project for me. I think Florence was looking for someone to do exactly what we have done here, and she found me. I was excited by what the woman had said and looked up a picture of the place. I found a picture, but it only showed the front of the house. I was so excited that I started sketching and soon had done two views, one from the front and one from the back. It turns out that the picture I drew of the back of the house was exactly right, even though I had not yet seen a picture of it, the back of the house…not at that time. I would not see a picture of the back of the house until later, yet I drew it as if I had it in my mind's eye right from the start. I just let it happen, and when I was done I was amazed at what I had drawn. It was cool!

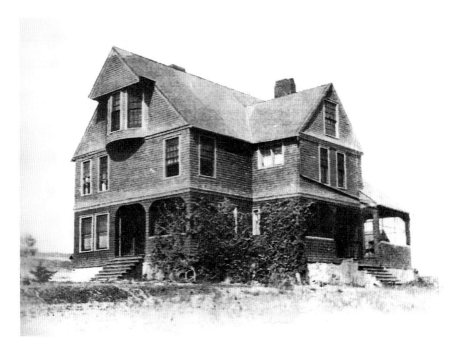

The Harris House, on Bradburn Boulevard, as it was before Westminster grew up around it. *Courtesy of the Westminster Historical Society.*

I had a great time touring the house with Bill, Debbie and Pat, looking through their pictures (orbs, orbs and more orbs in many of them) and seeing the places where the ghosts of the house had made themselves known. As it happened, Debbie had arranged to have a visitor join us, and she put some icing on the creepy cake that was my evening on Bradburn Boulevard.

Maru G. is a close friend of the family living at the northern end of Bradburn. In talking to her, I could see why. Maru was effervescent and excited to share all that she had known and experienced throughout her life. She joined Debbie and me on the restored third floor of the home, where we had been going through the extensive family photos of their construction efforts. She pointed out that a piece of furniture on the main floor of the house had come with someone attached. Debbie, somewhat startled, mentioned that she had just bought the chair, a kind of lounging couch. Debbie had really liked it in the store, but whenever she sat in the chair with her eyes closed she got a sort of wavy feeling, as if she were a little disoriented. Maru explained that was because it had an attached ghost: "Sometimes ghosts attach to objects. It is a young girl, about fifteen, with a long dress from the early 1900s. She is very demure."

The Ghosts That Stalk Suburbia

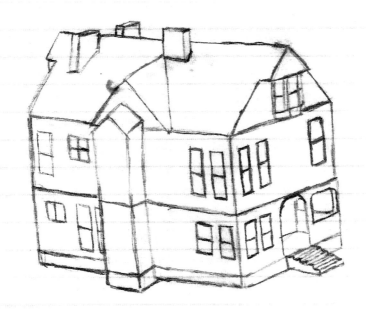

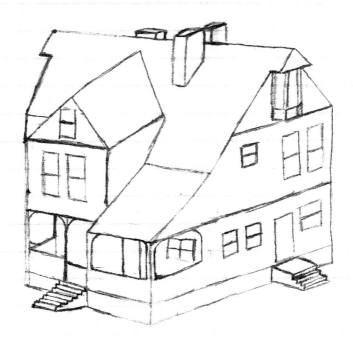

Soon to be the owner of the house, Bill drew two different views of the building, even though one of the vantage points was one he had never seen before. It's amazing what one can do when the ghostly owner is acting as inspiration! *Photo courtesy of Bill T.*

I was curious to know how she had determined that the ghost was demure, so I asked. You know I am very particular with my words, so my question was something like this: "Maru, how do you know the ghost is demure?" Do you see how I get right to the heart of the matter? Maru, noting the piercing clarity of my question, provided me with the answer: "She kept her head bowed, with her eyes downcast, and did not lift her head as I went by her. I think she might be an imprint rather than an actual ghost. The imprint is attached to the chair."

I remembered the ghost echo I had learned about in the Sheedy Mansion in Capitol Hill and mentioned the circumstances to Maru. Although she used a different term, she confirmed that the concept was the same. There was no actual sapience attached to the couch, no one there to respond or have any awareness. There is just the memory of someone and her emotions attached to the object. Listening, Debbie told me that she had gotten the lounging couch in a design center. The proprietor, who collected many antiques, said it was more than one hundred years old and had come from Kentucky; that's all she knew about it.

Maru went on to say that another ghost—a woman—haunted the main floor but that she had not been able to glean anything more about her. Debbie told her it was likely Florence, still minding the homestead, and our evening began.

Up until recently, Maru has worked at the Seventy-third Avenue Theater Company, at 7287 Lowell Boulevard in Westminster. She was a producer there for three years, working on musicals, plays and all manner of theatrical offerings. Her time there was not only filled with ebullient actors and attentive patrons but also with ghosts of just as many temperaments and talents:

> *We had electricians come into that theater all the time, and they could never explain all the problems we had with our lights. They would work one moment, not the next, even though all the wiring was good, the lights were good, everything fine. There was nothing wrong, at least not that the electricians could see. I knew what was happening, though, because I know that building is filled with ghosts. I see them and hear them. Even when I can't see or hear them, I still know they are there. One of the adolescent ghosts just loved to play with the electric board, and there was a ghost of an older gentleman backstage who would mess with the lights in that area. There were more ghosts there than I could even identify, and they were all busy with their own mischief.*

The Ghosts That Stalk Suburbia

Though the Seventy-third Avenue Theater is not large in size, the ghosts within are numerous. All of them are eager to take a final bow as the building bids adieu to Westminster.

With so many lights going off, being unreliable and just plain troublesome, Maru would frequently have to request that the ghosts leave the lights alone so a performance could go off in something other than total darkness. The ghosts usually complied since Maru was speaking to them directly:

> *Things were always moving, falling, disappearing. It happened so much and so quickly that I could not stop the ghosts from doing it. Most of the time, however, they were obedient, not really wishing to disrupt the art of the theater we were producing. Sometimes the ghosts would talk to me, even interrupting me, and other times they just went about in their own world, unaware.*

Debbie described one of the incidents of the ghosts interacting with Maru at the theater. She, along with her stepson and one of her dogs, was out for a walk and dropped by the theater to say hello. Though she and Maru were chatting amiably enough, Debbie noticed that the dog was staring fixedly at

a particular area off to one side, paying no attention to anything else and poised very stiffly, almost defensively. After a minute or so, Maru turned to look in the same direction, saying, "I told you, not now! Now is not a good time. I will talk to you later, so please go away now!" Then, without another missed moment, Maru turned back to Debbie and continued the conversation they had been having. Debbie noted with a chill that as soon as Maru had concluded her outburst, the dog had stopped looking fixedly in the direction of Maru's chastisement. Now the dog was looking for attention from her stepson, acting like a normal, unconcerned dog.

Maru laughed when Debbie told me this account, not remembering the incident. Too many things had happened in the place to remember them all, she explained. She went on to say that ghosts, just like people, sometimes act impatiently and without politeness: "One ghost I had to yell at all the time was always peeking through the curtains to watch the audience come in, which is really tacky in the theatrical world. He had no respect for the place or the people."

I stopped by the building later. It is not large, and in fact the building strikes me as not having originally been a theater. All the same, it has had a long run and seen many fine performances, both physical and spiritual. As with those of us who are living, however, the place's days are numbered. The Seventy-third Avenue Theater Company's building is slated for demolition in August 2012 so that Westminster may develop the area, along a busy and popular corridor, into housing and retail:

> *The ghosts in the theater know that the building is going to be torn down, and they are probably sad about that. The energy of the place has changed; it's wrong now. It is lifeless, void. The brightness is gone out of it, leaving it listless. The ghosts can't change what is going to happen, since the choices are being made by the living.*

Though I would learn a good bit more about Maru (and you will too in a bit), we must now leave Westminster behind. There are many more jewels in the city's crown that I have not yet touched upon, and I am certain there are more ghosts. So far, those ghosts have not shown themselves to me, and you know I never go *looking* for them. So, we must return to one of the ladies I mentioned earlier and jump across the map to another section of the Denver metropolitan area. This part of the metropolitan area is toward Brighton, but not in Denver, in that vast swath of land that is sort of in between it all. As for the lady, her name is Laurene, and she was the one who appreciated

my megaphone. As you will recall from the introduction, I was riding the shuttle when Laurene struck up a conversation with me. On another day, I got to rejoin Laurene. She even brought her mother, Mary, along, and they told me about their experiences growing up along Riverdale Road. Mary recounted everything succinctly and clearly:

> *We moved to 9000 Riverdale Road in 1965 and lived there until 1972. It was not a long time, but it was a powerful, memorable time. We raised our family and took care of our lives, but we were not alone in those efforts. The ghosts in the place took care of us as well.*

Originally, the family moved into the house not just for a home but also with the intention of raising horses. Mary's husband had long worked in this field and enjoyed it. The house on Riverdale Road offered ample space for the horses and for the growing family. The place was a bit of a wreck when they got there, but it clearly held great potential. The family moved in, cleaned, built fences and settled down to what was assumed would be a quiet, bucolic life. They little suspected that the place came with ghosts who would be protecting them, but the evidence arrived on the backs of crashing waves brought forth from the nearby banks. Not far from their home was the South Platte River, running placidly from the mountains through Denver and then by their home on its way toward Nebraska. The problem with the South Platte River at that time was that it did not always run so placidly. The summertime flood of 1965 was a costly disaster for Denver, with crashing destruction visited on almost everything in the water's path. Some things, as Laurene recalls, were spared:

> *All the fences we had just built were gone. We never saw even a little piece of them again. We let out all the horses as the floodwaters approached, so they could save themselves, and we got as high in the house as we could. The water just came barreling over the landscape, and we could hear trees breaking. The water came right toward the house, showing no signs of stopping. Yet the water did stop; it rolled right up to the very edge of the house and stopped, plain as anything, and never came back. We didn't see anything stopping the water, but all of us knew that someone within the house had pushed it back, saving us and the house. That was our introduction to the ghosts here, and I will never forget it. It was big.*

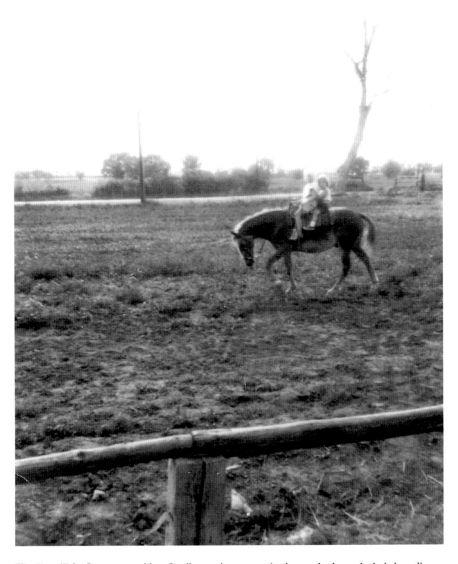

The "yard" for Laurene and her family was immense. As they rode through their bucolic home, they had little thought of the approaching disaster that would sweep away their newly built fences and demonstrate the type of guardian a ghost might choose to be. *Photo courtesy of Laurene L.*

Laurene and her brother, Jimmy, knew they were living someplace special. Even as they cleaned up from the flood, they looked at the place with a new respect and awe at what those within the house had been able to accomplish. Soon, Jimmy turned up some possible answers for who was protecting them:

The Ghosts That Stalk Suburbia

We didn't have a yard as other kids might. We had acreage! We roamed and explored, played with the horses and made the area down by the river our home. There were giant cottonwood trees here and there that had survived the flood, and all kinds of bushes, so it was perfect for kids. Jimmy and I would explore. He had a special knack for finding things that I would just walk over without noticing. Jimmy was always finding arrowheads. We thought the area must have been a place where the tribes had stayed long ago, and both of us wondered if they were still around, taking care of us.

Both children frequently felt they were not alone in the house, even when they knew that they were. Others coming into the house would also comment on it, how the place felt somewhat protected, touched by some special boon that other places could not claim. All the same, even the most attentive ghosts miss something every once in a while.

Mary, who said that she felt the protective energies of the house as much as her children did, described how one of the ghosts followed her to a small fenced-off area near the barn, perhaps in anticipation of what was to come:

I was milking the cows, as I often did, not thinking anything about anything. There was a thunderstorm nearby, but we never had lightning strike the house. It would strike the trees in the distance, maybe, but never the house. So, I was not really worried, not thinking about the storm. It was a cool day, so I was doing my milking of the cows outside. Nothing much was happening, and it was not even raining. All the same, as I was milking one of the cows, it jumped forward as if it had just been slapped. This startled me and upset my balance. I fell backward and rolled a bit. In the next second, right where I had been milking the cow, a fork of lightning struck the earth with a deafening boom.

As Mary's senses reeled from the combination of brightness and sound, she was nevertheless aware of the fact that something had saved her from the lightning just in time.

On another occasion, the ghosts and their wards surrounding the house were not capable of keeping something from entering. Laurene recalled:

My brother, Jimmy, and I were at home with the dog. Our father was at work, and our mother was running an errand. We were downstairs in the main living room when Boots, the dog, just lost it. He just went out

of control. Normally he was a good dog, very mellow, but he would not stop barking. The strange thing is that he was not barking at a window or something outside; he was barking at something inside the house. We were really scared. Jimmy was a teenager by this time. He got his gun, and we went outside, moving a little ways from the house so we could see the front door and the side door, too. We stood there, under a cottonwood tree, until Mom got home. She asked us what was going on because Jimmy had his gun pointed at the house and Boots was still growling and barking. Mom took us in, Jimmy almost dragging the dog, and as we came in the front door, we heard loud thumps from upstairs, like some great weight falling to the floor. A commotion followed, a series of loud bumping noises, then silence. We looked up the stairs but could not see anything at all. About that time, Dad came home, and we explained what had happened. Dad had had some things happen to him on the farm so knew there were ghosts about, but we had never really had anything inside the house before that time. We all crept up the stairs, except for Boots, who would not go up at all, and didn't immediately see any issue. We could not find anything that had fallen or what might have made all those thumping noises. Then Dad spotted it: on the ceiling was a series of dirty boot prints, walking along on the ceiling as a person walks along on the floor. Those boot prints had not been there before, and I don't even think we could have put those things up there with scaffolding, especially since the roof was over the gap of the stairs.

Laurene, her brother Jimmy and their perceptive dog, Boots, in their home on Riverdale Road. *Photo courtesy of Laurene L.*

The Ghosts That Stalk Suburbia

Despite these harrowing experiences, the family looks back on the days in the house on Riverdale Road as being some of the best in their collective memory, a time when the spirits around them kept watch over them as much as possible. Unfortunately, the good times they experienced there would not continue indefinitely. Since they were renting the property, they had no choice but to move out when the owner decided she wanted to do something else with the place. In leaving the home that had cared for them, they left more behind than simply walls and fields and horses; they also left behind their guardian ghosts. Tragedy crept in with no impediment to stop it, shortly thereafter claiming the lives of Laurene's father and brother in separate acts of violence within the community:

> *Whenever we get together with the extended family, everyone talks about that time as being somehow set apart from what came before and after, a blessed time. We have continued to live and perhaps carry some vestiges of the touch of those ghosts, but it has never been what it was.*

With the departure of Mary, Laurene and the rest of the family, something within the house fundamentally changed. It was as if an era had come to an end:

> *The house became a neighborhood eyesore almost right away. The next people to move in did not take care of the house or lands, and the results were very ugly. Although we heard rumors that the people were some cult, attracted there by the power and spiritual presence of the place, there is no proof of that. What we do know is that every time we would go by, the house seemed to be mourning. You could feel it; it was that palpable. Moreover, we could sense the ghosts were getting fed up with their new situation and the worthlessness of the new tenants. The house burned to the ground the following year, and we all knew that it was an act of purging, purification and release. Our ghostly protectors had left their homes and gone somewhere else, making sure nothing was left behind them.*

Laurene and Mary told me all of this over some Coca-Cola and croissants at a relatively quiet spot downtown. Once I had heard everything, all the way up to the sad ending of the house that had nurtured them for so long, I was curious to know if I could go and see the place for myself. They said it was not only possible but also that they would go with me to show me around what had been a life now more than forty years lost. What a shiny possibility!

Determined to get as much out of the experience as possible beyond just taking some pictures and hearing the recollections of my hostesses, I brought along the Big Gun. OK, her name is not really Big Gun, but it describes her mind pretty well, at least when it comes to ghosts.

You know her, of course, as Ivy. You read all about her life's experiences with the world of ghosts in my first book. Since that time, she and I have remained in contact, and I have continued learning about the supernatural world from her. When I asked if she would be willing to come along to the location in question, she graciously accepted. She even agreed to pick me up (since it would have been a *long* bike ride otherwise) and take me there. Laurene and Mary led us to the spot so no one would get lost.

On the northwest side of the road, houses stretch toward the horizon, marching blandly on and on without any visual interruption. On the southeast side of the road, however, the land is part of Adams County's open space. The land slopes gently downward toward cottonwood trees and the South Platte River beyond. We could even see figures in the distance using a bike path. With the short grass and the open feeling of the place, it was easy to imagine what it would have been like in the '60s, long before the houses behind us had stalked across the landscape. The long fence dividing the shoulder of the road from the open space was a wooden affair, evenly spaced posts with two long trunk-like beams between them. Lifting one foot into the gap and then bending to make our way through, we stepped back in time to a part of Denver's agricultural history that has been lost. No horses grazed, no barn and associated outbuildings stood ready to use and no farmhouse could be seen. As soon as we entered the dry expanse of grass, under an overcast sky that boiled slowly with meditative clouds, an eagle took off from the nearby cottonwood trees with a reproachful screech. It flew farther away from us and took up position in a tall tower holding electric wires high aloft. There it remained for the entirety of our visit, glaring at us from its remote perch and venting its annoyance in an occasional cry. The tree it had left held a massive eyrie. We were careful not to get too close to the tree.

As Laurene and Mary walked across the field, already deeply immersed in conversation, reminiscences and observations, I turned to Ivy. She was scrutinizing the place narrowly, though not with a look of displeasure:

> *As soon as I crossed through the fence, I left the modern world behind me. The fence is the dividing line between a spiritually dead place and one that is very alive, full of memories and a great deal more. There are many ghosts here, and they know that we have arrived. They are not interested in you*

> *and me so much, but they are regarding Laurene and Mary, and the feeling is of recognition. Time moves differently for ghosts, but even they are aware that some time has passed.*

Ivy described the scene in two very different ways. On the one hand, there were the fence, the road, the cars, the short grass and the empty spaces. These were the things she saw with her eyes. On the other hand were the things that she saw with her awareness beyond the mundane, what some call "the third eye." The term refers to an awareness of the world that comes through one's psychic attunement, a way of seeing with the totality of the mind rather than just the eyes. Ivy could see a great deal, and the field was an epicenter of activity beyond the veil dividing the two worlds:

> *There are many people here, many times in history represented. I see Native Americans here, camped by the river, feeding their horses on the grass and even the leaves from the trees. I see pioneers moving across the land, staying close to the river. There have even been people buried in this land, people traveling somewhere else so the markers were temporary and soon gone. This would look like an empty field to most everyone, but it is really very far from being empty.*

We followed Laurene and Mary around as they showed us the land that had been their home. There were two areas without vegetation. Though it took a while for them to orient, given how much things had changed with growing trees and sprouting subdivisions, they eventually agreed that the two areas pretty much corresponded to the locations of their home and their barn. A walk about yielded numerous signs that the area had been a homestead: pieces of brick, sections of pipe, small bits of metal. Mary and Ivy, being something of an age, remained near each other, Ivy listening to Mary's stories of life on the farm. Laurene explored more widely, and I did as well. I noticed remnants of a ladder nailed into the cottonwood tree in which the eagle had built its nest. The rungs were largely gone or fallen askew. I could imagine the woman I had interviewed climbing the tree as a little girl.

When I got back to Ivy, Mary had gone off to explore some with her daughter. Ivy said that she had picked up on something of Laurene's brother, Jimmy, from the stories Mary was telling and the energy of the place where she stood, surrounded by memories and spirits intimately attuned to the world reached after death:

Now Adams County open space, there are no apparent signs of the life that once flowered in this now green and restful slice of natural Colorado.

For the family who lived here, however, some signs may still be observed, such as this area without grass, where one of the farm's buildings once stood. Beyond, houses blossom into the distance, obliterating the prairie.

The Ghosts That Stalk Suburbia

Laurene has some psychic ability, it is clear, but the really open one in the family was Jimmy. I can tell that he was very aware of the world around him. He would find arrowheads and other secrets here on this farm in part because he was aware of the place on a deeper level. This place is very serene. The ghosts are happy here, and so this family was happy here as well. I know, from my own feelings of loss concerning my grandparents' farm, that Laurene and Mary must be filled with a lot of recollections.

A few moments later, Laurene came over to us in a state of delight and excitement. She held up a solid, though slightly rusted, horseshoe:

Look what I found! I was hunting up all our old haunts here from when we were children. I was retracing my route back from that stand of trees over there. I started thinking about my brother and looked down and saw this right there on the ground, right where I had walked already.

Thoughts of her lost brother filling her mind, Laurene found a sign that her quiet walk was not made alone.

For Laurene and her mother, Mary, it was both difficult and comforting to come home to Riverdale Road.

Both Mary and Laurene were quite taken with the horseshoe, but Ivy remained silent. We explored the area and talked some more, and after a bit our hostesses left, carrying with them their memento of a lost time and a much-beloved brother and son.

Mary and Laurene had left so Ivy could have the run of the place in silence. As their car drove away, Ivy sighed expressively:

> *The ghosts here are aware of us, and they accept that I am able to sense something of them. They recognize Laurene and Mary. Some of them were part of the cadre that protected Laurene, Mary and their family while they lived here. They appreciate that Laurene especially has really not let go of this place. Finding the horseshoe while she was thinking of her brother was their way of saying that Laurene needs to let this place go, needs to let her brother go. That horseshoe is a talisman, so she will always remember, but those days are gone, and she needs to move on without letting the memories hold her back. I think Laurene will be able to do so now, will be able to progress. The eagle is still watching us, and I think it's one of the highest*

The Ghosts That Stalk Suburbia

totems there were for the Native Americans. We have been here long enough. It was time for Laurene to let go of this place in spirit, and now it's time for us to leave this place in solitude.

So we did.

As I made my way home, I thought back over all the hauntings I had learned about in just these few chance encounters with people in my work. I didn't seek out any of them, and yet they all found me. Laurene and her family had guardian ghosts in their home on Riverdale Road. Debbie and Bill are rebuilding a home under the attentive eye of its original inhabitant. The Bowles House plays host to sewing women and art critics. All of these contributions to my book came to me unbidden and are greatly appreciated. As I left suburbia behind, I thought it almost seemed as if some ghosts were sending the spirits my way so that their stories could be told. Though I was not using the term in the traditional sense, I found it somewhat funny that I should end up having a "ghost writer."

II
SEEKING THE THINGS THAT SOUND IN DARKNESS

My explorations of the world of ghosts, though undertaken reluctantly and with occasional ill grace, have nevertheless allowed me to meet some amazing people who not only take their psychic abilities as gifts but also see the world in a different way because of them. So, through listening to them, I have come to wonder how much of my own understanding of the world needs to be modified. How would it be different if I, too, were a three? Do these people go through lots of undergarments, or do they get used to it? Do life's experiences move you along the scale one way or the other?

The psychic scale is not anything I invented. Rather, it was explained to me during my stay at the Lizzie Borden Bed-and-Breakfast in Fall River, Massachusetts. As you will recall, the ones on the psychic scale don't believe in any of this stuff, would not be reading this book and are dragged along on my walking tours by spouses. The twos on the psychic scale (yours truly) have had some weird things happen to them but don't actually have encounters as deeply realized (or appreciated, perhaps) as those experienced by the threes. The threes are fully aware, fully attuned. However they experience them, they interact with ghosts as you and I might interact in the line at the post office or in a phone conversation. The world of a three is richer in hue and dimension than the four-dimensional existence we call home.

That being said, the experiences a three might have throughout life are often unique to that person, as exceptional as I am from you. There are similarities between them, certainly. You can't make threes; you have to find them. Each one is unique. In this chapter, we will examine some of the

people I have come across in doing the research for this book. This chapter is less about specific buildings and more about experiences and worldviews. It is a journey into the minds of ghosts, ghost hunters and those who have something *more*.

For many people, their connectivity with ghosts begins when they are children. Laurene, who spent much of her growing-up years on Riverdale Road, was aware of things around her from a very young age:

> *I used to spend a lot of time talking to my grandmother, my mother's mother, even though my grandmother was no longer with us. My mother did not believe me when I told her that I talked to grandmother. Exasperated, because not even a child of three likes to be disbelieved, I described what grandmother was wearing, and my mother just went pale. There was no way I could have known about the outfit and details, no pictures. The only way I could have known was through having seen her.*

As she grew older, Laurene found her psychic gifts troubling and tried to turn them off, especially after the death of her much-beloved brother. The hyperawareness was simply too much for her young mind. Now a grown woman, she has been able to open the doorway, though cautiously.

Maru was also ghostcentric as a child, and as with Laurene, she had a space of time when she had to stop:

> *I am never afraid of ghosts now, but that acceptance has taken a long time, a lot of growth, to come to where I am. Learning all this is a gift, and I am thankful. I am lucky, so very lucky to know all I know. I grew up in a house full of women, many generations of women all in the same house. All these women were full of intuition and understanding, so the place was laden with this vibrant energy. All the same, I don't think the women in my family were open to the idea of ghosts and spirits, so the gift was there; it's just that their eyes were closed. They did not want to explore it, and sometimes that is all it takes to close a person off from what is out there. I am sure my mother would have been terrified to see and feel what I saw and felt when I was little. These things were all around me, but when I was a child, I was not prepared. There was a room in the house that seemed to have negative energy. I could not explain it, but I understood it. I would always run through that room to get across. I did not have bad experiences; they were just very intense. So, I closed my mind to it when I was about twenty and spent many years in deafness.*

Seeking the Things That Sound in Darkness

As an adult, Maru had jobs (as most of us do) and ended up working with children at a daycare center located in the Denver suburb of Aurora. When Maru came to the childcare center, her senses reawakened. She was more mature by then and had people around her to help her understand the return to this spiritual world of her youth: "I have friends who have studied ghosts all their lives and are psychics. I also have spirit guides, ghostly presences who stay with me. We all have them."

Looking around me to see if anyone happened to be frantically waving at me, saying, "See, here I am," I asked Maru to explain the concept of a spirit guide:

> *I was raised a Christian. I feel no conflict between these Christian beliefs and my understanding of the ways of the world or the other world I have discovered through my life. The light within us that makes us who we are, that is energy, the divine spark. Energy doesn't disappear, ever. It just transforms. You finish this life and then it is time for another life. People think that you die and go to heaven or hell. I don't believe in hell as someplace that you go after you die, at least not the way most people conceive it to be. It does not happen. Hell is coming back here, to life. Living as a human, the experience of being a human, that is gruesome. Life is difficult, with pain and torment and jealousy and loneliness, all the things we think of as hell. Heaven is making your way out of this place, not having to return.*

Maru likened the cycle of a life of lessons, death and rebirth to our moving through our years in school. You go to school, and you learn. In talking about the cycle of living and dying, the school year may be thought of as your life. Then summer vacation comes, which would make the first day of summer vacation equivalent to your death (which puts a whole pall on the idea of summer vacation, doesn't it?). You recuperate. You spend some time preparing for your next school year, which would be your next life. If you have not learned what you need to learn, however, or if you forget too much during your recuperation, you repeat the grade. Not the same life, exactly, but another life with many of the same goals. If you learned enough, even with some knowledge slipping away, then you proceed to the next grade, which would be a life of greater acumen, greater awareness. This is why some people seem born with wisdom. It's the idea of an old soul in a young body.

Spirit guides are people who have died, but they are not the same as ghosts. Classically represented, a ghost is the remnant of a person who has not been able to move on fully to his or her next iteration. Spirit guides

choose not to move on to a new life just yet; they stick around to help those who are making a journey through a lifetime. Once you die, you make a plan for your next life and the lessons you wish to learn within it. You arrange for exits from that life that may be taken if you have learned what you need to know. According to many of the folks I interviewed, there are three exits. If you reach the first one but have not yet learned what you need to know, you survive. Perhaps it was an encounter with a tropical centipede (eek!) or falling over a waterfall. You could have died, but you didn't. You thank your lucky stars and go on. In reality, this was your first possible exit, even though you did not recognize it as such. Your greater self, the cosmic self that knows the overarching point of your life, would have taken that exit if the knowledge that was sought had been attained. You would not have seen the centipede in time, and your encounter would have proven fatal; the tumble over the waterfall would have dashed your brains on the rocks—that sort of thing. Along the way, your spirit guides seek to help you. You are never alone.

I find this both comforting and disconcerting. We all have to do it from time to time, but at least we *think* we are picking our noses with no one around to see us. Just imagine what the spirit guides must be thinking around teenagers. Sheesh!

So the spirit guides are around you, according to Maru, Ivy and many others I have met over the years and interviewed as part of this journey of ghostly discovery. They are there to help you, if you pay attention and listen. Sometimes their contributions are quiet and subtle: "I ask them questions and get answers in the form of signs. If you are not paying attention, the signs pass you by, and you miss the answer you sought."

The similarities between asking your spirit guides or the universe in general for answers and praying for them are striking. Whether from God and angels or greater human consciousness and spirit guides, the answers seem just as real to those receiving them. Perhaps the terms and definitions don't need to be so rigid.

Having discussed the idea of spirit guides for a while, Maru then walked me through some of the peculiarities of ghosts:

> *Besides the spirit guides around us, there are also lots of ghosts. Many ghosts are able to attach to people and travel with them. When I was working at the childcare center in Aurora, I would see the parents coming in to drop off their kids. The parents didn't just have the kids; they had ghosts coming along with them. The ghosts would often stay at the center because the place was full of light and energy. The parents might have a ghost*

Seeking the Things That Sound in Darkness

> *tagging along because they were in a bad mood or simply because the ghost was looking for someplace new to be. Ghosts move around; they travel with people all the time. They look for better locations. If homeowners know that ghosts are there, they are able to make them leave, tell them that they don't want them there and that they have to go. Ultimately, ghosts are trying to find their way to the light. Sometimes they are fumbling around, unassisted. Sometimes people help them find their way out of their half-life. I have done this before for ghosts. In the meantime, they need energy to survive.*

Just as the childcare center attracted ghosts owing to its positive and abundant energy, the theater where Maru worked drew in crowds of specters as well as spectators. Lots of people came to the playhouse, and actors are sometimes very temperamental, so all this draws in more energy. Ghosts are engrossed by this.

Ghosts are fascinated by specific people for similar reasons. Bubbly and vivacious, Maru explained her own appeal to ghosts:

> *My energy is really high all the time, and I am rarely sad, upset, angry or any of that. I am very happy. That is very attractive for almost any spirit. Not all, of course. Some ghosts are very sour and would not want to be around someone like me. The good thing is that ghosts may choose to leave, as well. They have that within themselves, that free will.*

Just as people have energy and personality, so do places:

> *I can tell a place's energy just from entering it. When I enter a school, I know if the children are having problems. I know it immediately, in a person's home, in a business. Some places have energies and dispositions thrust upon them. The childcare center where I worked, in Aurora, was located on a place with lots of innate energy. Things would appear and disappear frequently, and it was not the children. We had to change the light bulbs all the time, that place had so many ghosts. The children would see the ghosts, too, even play games with them.*

Maru related one instance in particular of the ghost of a little girl who resided at the childcare center. Maru had a classroom filled with kids about three years of age, and she heard them talking about someone named Jimmy. She thought it was strange, since she did not have a student by that name, but assumed they were referring to another child they had been with

during the recess period, when the students from the whole school would hit the playground. When she kept hearing the name, she finally asked the registrar about the student, wanting to know who it was that her kids found so enthralling. She was told that there was no child named Jimmy then enrolled at the school. All the same, the kids kept talking about the fun they were having with Jimmy, even to their parents. Some of the parents began to ask who Jimmy was, and Maru, who by this time had an inkling of what was going on, deftly avoided the subject by saying there was no student enrolled at the school by that name. She knew the child was not enrolled, perhaps, but a different kind of child was there despite a lack of registration documents.

About the same time that the students were reporting fun with Jimmy more and more often, less enjoyable things were happening in Maru's classroom and in the center in general:

> *Things were getting knocked over, nothing too big, until a window was broken. At this point, I tried, because I had figured out that Jimmy was probably a ghost, to see him. I started looking for him. I had had my mind closed for many years, but the place was so full of energy. The kids were full of energy and life, and besides, they needed my help. So, I was able to reawaken. I thought I would see a ghost, and I did, but it was a little girl. I am not sure why the kids all called her Jimmy, but this was the culprit. She played with the kids, but she was also getting angrier for some reason and was causing more and more mischief. Since she had broken the window, I told her that she had to go. I asked for someone in her family to come and get her, and the ghost grandmother of the little ghost girl came to take her away. That little girl had such a tantrum, but this was after hours, so none of the kids were there to see it. After her hysterics cooled down, she left with her grandmother, and I never heard the kids talk about anyone named Jimmy again. Kids don't realize they aren't supposed to see ghosts, that they are not supposed to play with ghosts, so they just accept it and go on with their games.*

Never having seen a ghost (hallelujah!), I was curious how, specifically, one sees a ghost, especially as frequently and as consciously as Maru seems to be able to do. She said that, first of all, if you see a ghost, it is allowing itself to be seen. They keep their secrets and do not give them away accidentally. When Maru sees them, it is her eyes, her sixth sense and her sensitivity to the energies around her, all combining to make a composite awareness of who is there. She sees ghosts as she sees other people, but it is not physical.

Seeking the Things That Sound in Darkness

She could describe the person as readily as one she saw walking down the street, but it's through her "third eye," a commonly used term for this sort of superawareness. What her third eye perceives, her mind then translates into human expression. Even when she cannot see a ghost, she can still feel that ghosts are there.

Once Maru unbolted her mind again, one might say the floodgates opened. Many spirits in need came to her for aid. Debbie, with us for all these conversations, explained her thoughts on why this would be the case: "Maru has such a wonderful energy, you can see why something troubled would come to her for help."

Maru assented. Further, she had not just helped people to get to a better place:

> *Animals are very clever. Animals recognize the energy of a place, the energy of a person. They know where to go to get help. They recognize kind souls. We were always getting animals coming up to the childcare center. They would sit outside my door, the one that led to the playground, and when I would open the door, they would be sitting there looking at me. "May I help you? Do you want to come in?" The dog would come in, and since we could not keep it there, we would find its owner. This happened time and time again. Dogs and cats are equally clever, but cats tend to disregard much of what they see because of their personalities. When animals need help, they'll come to the people who will help them.*

Even if they have to come limping up to your door! It's funny, I always thought people whom animals came to for help must have "SUCKER" written on their foreheads or something in cat or dogspeak. Maru made it sound like much more of a prize.

Maru's vision of the world of ghosts and spirits is a very positive one, where your spirit guides never leave you and where the ghosts of those in your life who have died may, if they choose, come to help in your journey for a while. It was a lot for me to absorb. One of the thoughts that Maru shared with me stuck in my mind even after our conversation: once you open that door in your mind to the world around you, there are ways to close it, but you will never be the same again.

Now let's visit a fine fellow with an intriguing twist on his psychic gifts. I first met Don B. electronically as I was doing research. We chatted back and forth for a bit through e-mail, and then I had the good fortune to be able to sit down with him and ask questions about his life and experiences. Don met

me at his door and welcomed me into his home, where we were joined by a hefty and extremely friendly cat.

Don, who, I would say, was born in the 1930s, went through some difficult changes to his world in the 1970s. Faced with chaotic aspects in work as well as his personal life, he decided to begin writing about his experiences. He was also moved to explore the possibilities of existence. Although there had been no prior indication of being psychically gifted, he displayed a knack for touching something beyond our own little four-dimensional world. He found himself in contact with the innumerable spirits that surround us.

He began by taking some spiritual and psychic development classes in the late 1970s and early '80s. He took several classes with Jack Young, who taught in the Jefferson County Adult Education system. During each class, which took place in Jack's home, Jack would have a demonstration:

> *There were many of us students there, and we were all astonished to see musical instruments floating about, tables being raised off the floor, that sort of activity. There was no way we saw that he could be faking such things as we interacted with the items.*

One evening, Jack took the group to Dr. Bradley's. Though active in the medical profession, Dr. Bradley was also involved in the world of the supernatural and had helped with a book on the subject, *Psychic Phenomenon*:

> *We gathered in the darkened library on the first floor of Dr. Bradley's house as a group, staying quiet for a time. During this time, I saw in my mind many features of the second floor, including some furniture and a picture of an old sea captain. I told the group what I had seen. Then we went upstairs and saw everything I had seen in my mind, though I had never been in the house before.*

After that, Don's awareness continued to grow. His connections to the world of ghosts have almost always been achieved through his writing. He realized he was not alone, physically or spiritually. There were others out there as well. Some of them are, simply put, ghosts. They have finished their own times here on earth and linger on to share their wisdom or maybe because they are unaware that they are now "life challenged." Others were never living, as Don understands and describes it, and serve as guardians, guides, advisors and more. Whether spirits or ghosts or something in between, Don found their contributions to his life both welcome and overwhelming and has grown a lot because of them.

Seeking the Things That Sound in Darkness

In his writing, one of the ghosts that came to him to offer guidance a number of times was named Ilwaco, a member of the Assiniboine, a Native American tribe once residing in Washington State. The name Ilwaco is now carried by a city in the area. Others have spoken to Don through his writing, enabling him to grow as well as help others. He helped a friend determine why she could not lose weight and another understand what would come up in a new relationship. Don gave his writing to the man in the new relationship, and Don sat back to watch the things the spirits had told him about the couple's future come true. (Don't worry. For the romantics among you, it was a happy ending, though not without convolutions, all of which Don had foretold in his writing.)

Over the years, Don has written numerous small essays. He calls them his memoirs, since he is part of a writing group charged with the production of little vignettes from one's life. These are shared with other members of the writing group. During his mental explorations, Don has also frequently opened his consciousness to the ghosts around him, allowing them to communicate what they thought he needed to know or just whatever happened to be on their minds. Don was gracious enough to share some of these writings with me.

Some of the insights into the future have been quite momentous, such as the large earthquake that will strike California in this century (the ghost's comments included some of the aftermath of that disaster, which made for some spooky reading). Other conversations have been more personally focused on Don and his life, sometimes almost surprisingly prosaic. Frustrated about a set of calculations that he was charged with completing for work, a numerical table that was just not working out, the ghosts gently pointed out the incorrect number that was causing the issue.

The ghosts of relatives gone before sometimes offered the insights: "There is much knowledge to be gained through your work [in communicating with us]. Let the still, small voice come through you. We love you and have much to impart to you. Do not be afraid or close the channel we bring you."

Don's touch with the supernatural made me feel good, since the ghosts he has encountered have really done right by him. Not all ghosts are so helpful and considerate, though. Long ago I would have thought all ghosts were about the same, just nice or not nice. Then I learned about ghost echoes, but that's not all! From one of the fine folks I was able to interview, I learned that there could very well be as many as four classifications of ghostlies in the world. Maggie S., whom I interviewed about the Grant-Humphreys Mansion, the Byers-Evans House Museum and more, was willing to share

much of her knowledge with me. If there were a rating higher than a three on the psychic scale, I suspect she would be there:

> *If I can re-create a ghost experience myself, then it's out. If it's a natural event that can be re-created, then it is not a ghost. I am an absolute 100 percent skeptic. I have to be. That being said, there is a lot going on out there.*

There are four types of haunts: true ghosts, which possess intelligence as any person does; residual ghosts, which are merely imprints on reality (and which I call ghost echoes because there is not really any mind there, and they repeat the same things over and over again, without variation); poltergeists (which Maggie doesn't believe are ghosts at all but are actually manifestations of the energy of the living on the world around them, especially emanating from adolescent girls); and inhuman haunts, which have never been humans. Inhuman haunts are not the ghosts of someone who has died. Within that category, there are secondary classifications: demons, angels, spirit guides and elementals. Elementals are tied to the classical elements we all think of, and they do not manifest in our world unless someone calls them. Whichever element you are talking about, elementals are nasty things, according to Maggie. They are powerful forces. With ghosts, there are actually many ways to see them, though "see" is not always the most applicable word.

Sometimes a ghost will appear as you and I do, with all the indications of three dimensions and being completely solid, though they are immaterial. Some bear the classic transparency we associate with ghosts from watching too many Scooby Doo cartoons as children. Yet for all that, there are many more forms of manifestation, from common orbs up to what Maggie called "shadow people." Shadow people are humanoid in shape, but they lack color and definition, instead being more of a mobile grayness, like a lighter shadow. There are three common types of shadow people: the darter, which is small and moves in quick, furtive jerking movements; the monk, a tall figure wearing some kind of shroud; and the third (which Maggie has encountered the most), which ghost hunters call "the man in the hat." Their shadowy forms flow without alteration from body to haberdashery, and their heads are shaped like bowlers, top hats or some similar chapeau. I asked for a little clarification and learned that though one of the shadow people classifications is called "the monk," that does not imply any actual connection to a religious order or person who served within one. It is just a term based on the shape of the apparition.

Seeking the Things That Sound in Darkness

Maggie's exploration of the realm of ghosts has not been conducted as a soloist. She has had a lot of help. One of the most important figures in her growth was a friend named Debbie, a gifted intuitive. Though Debbie passed away, she has still been able to help Maggie on a number of occasions:

> *We had one* [of the shadow people] *that attached itself to our family, followed the ladies of our family around, sometimes daily. With a threatening demeanor, it was trying to scare us. I was not a fan. After the fourth or fifth time he came to scare me, I was just fed up with it all, and I asked Debbie to help me. At that moment, I was seated, my back to a wall. I felt energy shoot out of the wall next to me and attack the shadowy figure of the man in the hat, dispersing him. He just dissolved, and afterward I smelled a powerful and, at least at that point, unknown fragrance. Haven't seen the creep since. The very next day, I went to visit Debbie's widow and mentioned the incident. She smiled at me and took me to where Debbie had kept all of her perfumes, toiletries and such when she had been alive. "Was this what you smelled?" she asked, opening one for me. It was a rich and expansive smell, the exact one that had poured over me after the destruction of the shadow. I told her yes, and she confided in me, "She only wore this oil when she was doing her most powerful work, something very important." The connection was very moving, very powerful; I was allowed to keep the bottle as a memento of my dear friend, who's still out there watching out for me.*

Some are of the opinion that, although they exist, you never actually meet an inhuman haunt, but Maggie does not hold to that. She was careful to clarify that she does not dabble in anything that would summon such an abyssal entity, but she has met up with them all the same.

Though encountering a ghost may be a disconcerting experience for many, maybe even terrorizing, some of those experiences are very personal, carrying a deep impact. When I interviewed Maggie, the first haunting she related was, naturally, the one that had touched her most personally. I believe most people would feel the same.

Maggie and her grandfather were not on particularly good terms when he died. For a while, he had not been the best or kindest of men to anyone. Maggie, feeling the sting of his treatment of her, did not attend his funeral and thought that aspect of her life was now closed. Though he had not lived very far from her, she had not wanted to have anything to do with him. Nevertheless, shortly after his death, everyone in the family began noticing a particular trend in their lives—pennies:

My grandfather had been into pennies; it was one of the things he really liked. We started finding them everywhere, especially when we would make a strong choice or have something pivotal happen to us. The whole family knew who was doing it. We knew he was trying to atone for what he had left undone, how he had not taken care of us when he had the chance. He was trying to do right by us.

In leaving the pennies (or cents, as the fellow at the U.S. Mint was so careful to point out to me, since apparently a penny is not an American unit of currency), Maggie's grandfather was guiding those he had left behind him. Not in the breadcrumbs sense, as in "follow this trail to your destination," but in subtle indications that they were going the right way or, if the way had already been taken, that the steps were correct and were ones of which they should be rightly proud. We all find cents on the sidewalk from time to time, but the preponderance of them in Maggie's family's lives was enormous and bore the emotional impact of a man trying to do better.

In 2006, Maggie had a dear friend die from lung and brain cancers linked to her smoking. Her name was Debbie, and we touched on her a bit earlier. As Debbie lay dying, she made a request of Maggie. Maggie complied, as anyone would when faced with the stark reality of losing someone so intrinsic to one's being. Maggie promised Debbie that she would quit smoking to avoid the chance of Maggie experiencing the same fate. The light of day and demands of common life are sometimes too much for any of us, however. Despite the promise, Maggie has not yet made a clean break with smoking. The lure of the ciggy treats is, at least so far, irresistible:

I was doing really well, had quit for a while, but then another friend died, so I was unable to continue my efforts. His death hit me very hard, so I fell into an old and comforting habit. After I got back into the smokes, I could hear Debbie's voice in my head. I'm not mental; I've been tested! Even though she was reminding me of my promise, I was not able to resist. So, while I was sitting there smoking one night, ashtray in one hand, cigarette in the other, Debbie showed up and knocked the ashtray out of my hand. It just went flying. I looked at her and told her, "I know! I know!" The ghosts of those who love us come back to help sometimes.

Maggie ruefully acknowledged that Debbie might have to smack her around a little more before she is finally able to quit, but with help she's getting there. Perhaps this is the missing step for some people's twelve-step

program. It would be fitting, I believe, for a paranormal element to wind up on the menu as the thirteenth step.

Another time, with a friend ill in the hospital, Maggie checked herself in the mirror as she was heading out and saw not her own reflection (oval face, short dark hair, rich brown eyes) but the face of the friend in the hospital (aquiline features, long ice-blond hair, pale eyes), and she knew things were not going well for the woman in the hospital who bore the face she had seen in the mirror. As she began to cry, Debbie came to her again, letting her know that things would turn out well. Maggie has often been so fortunate as to receive such aid:

> *We have spirit guides as well; one of mine is a very enthusiastic Hindi gentleman who uses very modern words sometimes. If we listen to them, there are many people who come to help us, those who have gone before us. Debbie has been around, helping me for a while. I was out on a second date with this fellow, and when we kissed, my nose started to bleed. My nose never bleeds. It was my first bleeder, yet it bled for three hours, on and off, and I could not get it to stop. About halfway through the ordeal, I heard Debbie and a Greek chorus of my spirit guides telling me that they were doing this to protect me. While my mother and I discussed whether or not I should go to the hospital about my nose, I considered what I had heard. When everything was done and settled with my nose, I took some time and looked into this guy a little more. Turned out he was really a bad piece of news, and getting away from him was a good thing.*

Maggie pointed out that many ghosts and spirit guides, such as her Hindi fellow, even if they did not live in a time concurrent with our own, nevertheless learn our vernacular and are able to communicate with us using the terms that we would call representative of our daily existence.

Maggie has a lifetime of association with the comedy and tragedy of the stage, having performed in multiple venues both local and not so local. In one of the non-Denver theaters (which she asked I not name), there was a particular room that boiled over with the vilest of energies, seething with ghosts that were very aggressive and protective of their home turf. Since the room in question was a resource area for the general maintenance staff, Maggie had infrequent reason to enter it for her own purposes. She and her colleagues would habitually spread out within the theater to practice their lines and blocking. During a production that had a very large cast, the rooms for rehearsal were in short supply. That being said, Maggie had

no intention of practicing in that room and never did. Quickly, she and her co-worker passed it by and found a spot to sit down and begin their lines. On that particular night, however, passing by was not enough for the ghosts. Unfortunately for Maggie, one of the ghosts apparently thought she had still gotten too close. She and her colleagues sat down to begin their lines, but Maggie's real ordeal was about to begin, and it had nothing to do with forgetting lines:

> *Suddenly, I felt these claws pierce my back in three places, two between my shoulder blades and then one a little bit down. I was in pain and naturally startled. I stood up, and it felt as if I was wearing a backpack. Unable to concentrate on work, I called off the separate rehearsals, and we regrouped downstairs. By the time I got there, I was pale, sweating and could barely stand up straight. While we said our goodbyes, while I was putting chairs back, while I was turning off lights, this thing was attached to my back. With everyone gone, I stayed in the lobby of the theater, just sitting there focusing, trying to get rid of it in all the ways I know to do so. It would not go. It kept whispering in my ear what it was: it was an elemental. It was the element of air, riding me like a dead weight wrapped within my flesh. I was so terrified that I finally could not think clearly and called a friend to come and pick me up at the theater. I sat outside, too frightened to be in the theater alone.*

Unwilling to drive home in her frail condition, hyperventilating and weak, Maggie had called her friend. Meghan, who is a mentor of Maggie's when dealing with ghosts, arrived and helped Maggie to her car, which was located in the parking lot on the opposite corner of the intersection. As they were getting situated, Meghan was trying to get the energy off Maggie. Maggie was doing the same. Finally, part of the piercing energy pulled out of her. Nearby, a streetlight flashed and went dark. She told Meghan what had happened, feeling weaker still. The same progression happened two more times, with the quick removal of serrated blades, the flash of light and then darkness from the nearby streetlight, finally leaving Maggie drained but relieved in the hands of her friend.

Despite this encounter with the minion of an angry ghost, Maggie has continued her work with the supernatural, both on her own and with various ghost-hunting groups. You will read some of her building-specific experiences in the next chapter. Having heard about the helpfulness of her mentor, Meghan, I asked Maggie if I could know more about her and how

Seeking the Things That Sound in Darkness

Maggie had learned from her. Maggie said she could do better than that: I could talk to Meghan for myself. So, another connection was made between the accidental ghost hunter and those who go mano-a-mano with the not-so-physically-with-it.

I had the chance to interview Meghan, for which I was quite grateful. Though she is Maggie's mentor in many areas, she is mentored herself. I learned, through talking with her, that there are always insights to be gained. There is always some more progress to make. Meghan described an event that illustrated this quite well. After leaving work one day, she was walking to her car and got, as she called it, the "heebie jeebies." This feeling was rare for her, for she was accustomed to her attunement to the world around her. The sound of a passing car ricocheted off the walls near her, further startling her, and she had the sense that she should not go home. Something was with her, and if she went home, that something would come home with her as well. So she drove around for a bit. Her spirit guides told her to find a park, someplace dark, and upon arriving, she contacted a friend who is also very intuitive. She described to him what was happening, and he encouraged her to trust her instincts on this one:

> *I got out of the car and walked around some. After a bit, I had the feeling that I had shaken whatever it was, so I called my mentor. He told me that the attachment had taken place because someone was looking for help, and that this sort of thing would not happen to me again. I was troubled by that, thinking that surely this was the very reason I was here, to help people. Isn't that why I am attuned to these things? Then, while we were still talking, I felt it return. I was still outside of my car, there in the park. I turned around and saw it running toward me, long, knife-like fingers, coming right at me.*

Meghan, still on the phone, was getting lots of input at this point. She was talking to her mentor, who was frantically trying to guide her, and a terrifying apparition with inhuman hands was approaching her. Her mentor was almost screaming at her by this time, reminding her that everyone has inherent protection. As the approaching figure reached her, it bounced right off her mental energy, a shield flashing into brilliance around her—only for the menacing figure to come at her again:

> *My mentor finally yelled at me, "Call the light!" So, I did. I was standing in protective light, and the spirit following me was testing the boundary.*

While I was within this area of safety, Jesse, my mentor, was able to talk me through what had happened. The fear of the situation had made me think that something was bad. When people don't know what something is, they think it must be bad. After he had talked me down out of my fear, so to speak, I looked at the creature again. The vision had transformed. It was now just a woman in a flowered dress. She did not understand that she was dead. It was traumatic for me, but I imagine it was worse for her. She kept coming after me, unable to understand why this was happening, trying to talk to me. I called the archangel St. Michael to come and take her to the other side. She was, at first, a little reluctant to go because she still did not understand what was going on, but eventually she did. I went over to Jesse's, and we had some tea. We spent three hours calming me down.

Meghan told me a lot about her understanding of the world around us. Everyone has protective energy. People can develop it; they can make it stronger. When children pull the blankets over their heads at night, making them feel better, they are also working on their mental strength. The spirits around us may not mess with us unless we invite them, which is why television shows where ghost hunters tease whatever is in a place are really not helpful. You are tempting something to interact with you, possibly even attack you. When you provoke spirits in that way, in an atmosphere of teasing or fear, you are not necessarily getting the spirits as they really are. What you give is what you get, even in the world of spirits.

Ghosts, spirit guides, angels—the voices out there to guide us are numerous and arrive in myriad forms. Some are direct, as with Debbie appearing to Maggie audibly or visually. As Maru explained, sometimes they come through signs. The beliefs around the world are as diverse as the cultures themselves. Ultimately, you are never alone. So, open your eyes and your ears to a different world; those within it are trying to tell you something.

III
THE GHOSTS THROUGH THE DOORWAY

When I was young, I had no great thought one way or the other on history. It was a subject I found easy enough but not one that called to me in particular. Traveling the world changed my view on this matter. I realized that though I considered myself reasonably conversant with world history, I was, in fact, sadly deficient. Everywhere I went I met folks who knew all kinds of things about the history of the United States, even things I did not know. Yet I could not return the favor as impressively as they could. So I determined to learn more. Later on, I would meet people who would help me acquire an appreciation and knowledge of Denver history specifically and Colorado history in general, which is ultimately how I came to be in this profession and writing these words.

History opens the doorway to so much. The study of history allows us to understand and appreciate things that would otherwise be lost to us, as if our lives were the first time things have been discovered, shared and experienced. The very idea is ludicrous: most every element of our human experience today has been experienced before. Not everything, of course, but almost everything. Retracing our history opens these doorways for us.

So, though I am an easily frightened guy who hopes never to see a ghost at all, I am nevertheless thankful to some degree to the ghosts, for in learning about them, I learn more about history.

Leaving behind the philosophies of many a three, we return to the general core of Denver now, though not exclusively to the Capitol Hill or LoDo areas. Here, too, I have found some more stories to share. Very importantly, it should be noted that there are some stories I learn that I do *not* share.

There are a number of very important buildings in Denver, historic in nature and quite well known to be haunted, that do *not* wish to broadcast this fact to the general public. I do not believe in relating ghostly encounters that I am unable to substantiate through interviews or find in the public record and writings of old. Similarly, I do not believe in disrespecting the wishes of a haunted locale. If they don't want to be known as haunted, I will not promote their haunted status. Thus, there are a few glaring holes in my writing. Born out of respect for history and my colleagues in my work, those glaring omissions must remain. Thank you for your understanding.

So, in the dynamic city that is Denver, let us start with the experiences of a woman named Delores.

Delores A. grew up in a small farming town over one hundred miles from Denver. Having failed to get passing grades at her mother's alma mater, Delores' parents sought another solution in some degree of exasperation. The year was 1961. They eventually settled on Barnes Business College in downtown Denver, which used to be located in the heart of town. They had picked the school based on an advertisement that they had seen in the newspaper. In large letters and in italics, the school extolled its virtues: "*EARN A DEGREE IN ONE YEAR GUARANTEED*; you will receive personal instruction from seasoned instructors at this first-rate state-of-the-art school for professionals."

The "seasoned" instructors, to Delores' dismay, were octogenarians who looked as full of vitality and humor as the gargoyles that graced the exterior of the building. Nevertheless, the paperwork was filled out and the tuition paid, and Delores' parents took her to a small house in Capitol Hill that had been transformed into apartments:

> *We were told it was just a short bus ride away in a nice part of town, and that the president of the school herself, a Mrs. P., stayed in the building too. My parents, hearing the word "president," were filled with admiration. That was enough for them!*

After her parents had driven away, she entered the foyer of her new home, finding tall mahogany doors, the chandelier above covered in cobwebs and the light feeble. She introduced herself to her new roommate, Elizabeth, and they ascended the stairs so Delores could see her new lodgings. They fell into an easy patter about themselves and the various things important to young women verging on their twenties.

Their shared quarters had tall ceilings with ornate wallpaper and an ugly fireplace. A large window faced the street, and the bathroom was a

throwback to ancient times, with clawed feet that reminded Delores of the gargoyles at her new school. Within the shared closet, behind the hangers of clothes, was a safe where Elizabeth kept valuable possessions. Delores could use the safe as well. She was surprised to open the safe on her first try; the more to then find a gun inside it: "Elizabeth laughed at my shocked expression. She explained, 'It's for things that go bump in the night.'"

Delores did not know, at the time, just what kinds of bump they would be in for in that room.

After two months of attending the business school, she began her work-study using the skills she was learning through practical application. In this case, it turned out to be a mortuary owned by the president's brother, Willard. Though appalled by the idea of working near the dead, she needed the money, as well as the experience, so took the position.

The duties were simple enough and did not come without perks, in a fashion:

> *Every once in a while, long after a service had ended, I would take home a funeral arrangement of flowers that had been left by a grieving family, far too emotionally distraught to really care. The flowers added a sweet, heavy fragrance to Elizabeth and my living quarters, helping mask the choking air from the old drapes. Most of the floral arrangements I took were not all that special, but one evening I brought home a huge bouquet of calla lilies, white mums and baby's breath. It didn't look too bad once we removed the white ribbon embossed with gold lettering that read, "Beloved Friend."*

Elizabeth was quite taken with the arrangement and asked Delores for details of the departed. Not really knowing anything about the person at all, Delores entertained them both with a story of a friendless man who happened to fall into conversation with the owner of the mortuary, Willard, and his sister, Mrs. P.:

> *We were having a great time, since both of us knew the president of the school, and I had to work with Willard. I constructed a story of how the old loner had one day confided in Willard, my boss, that he had amassed a huge fortune during his lifetime. Willard then courted his friendship all the more assiduously, and the president of the school got involved as well, suddenly quite interested in the man's life, his well-being and his history. Willard assumed the old man would compensate them for making him feel a part of their family rather than leaving him luckless and friendless. The man was not interested in paying for their friendship, I said. I wove*

my story for our entertainment, full of extremely over-the-top melodrama. They got into a terrible fight, and Mrs. P. walked into the room just as Willard struck and killed the old man. Then they loaded the body into a hearse, placed it in a fine coffin and had a funeral under a fictitious name, complete with a magnificent floral arrangement, ostensibly from many devoted friends. We laughed so hard at this silly story that Coca-Cola came out our noses.

Delores had no reason to think that her harmless little story about two people she didn't really like and a bunch of extravagant flowers was anything more than a piece of meaningless chatter between two friends. While her boss and the president of the school had not heard the story, someone had and decided to make his presence known:

That night, as I lay in bed, I awoke from a deep slumber when I heard the floor in our apartment creaking. I blinked several times, trying to clear away the fog from my eyes, or what I thought was fog. I needed to assure myself of the vision before me. The dark outline of a man dressed in a long coat and a wide-brimmed hat was moving cautiously toward us through our bedroom door. Assuming it was a burglar and fearing for my life, I coughed and tossed in my bed, hoping the intruder would think I was stirring and about to awaken. The cloaked figure stopped and slowly backed out of the room. I waited for a few minutes to be sure he was gone and then, in a shaky voice, I called to Elizabeth. "Please wake up, Elizabeth. I need the gun!" I hissed. She whispered back that she had seen it too. Together, we sprang from our separate beds and raced for the closet, pulling the string on the light bulb, throwing back the clothing that hid the safe. The first try to open it was futile; we were too agitated, fearing his pounding approach at any moment, but it opened on the second go. She grabbed the gun and pointed it toward where we had last seen the intruder, outside the doorway, in our little living room area. Her hands were on the gun. I put my hands on the gun, and we walked forward in a near faint, checking all the doors and windows. They were all secured, locked from within with latches that could not have been closed from outside. We were both terrified. How had this shadowy form entered our room and left without any possible form of exit?

Delores and Elizabeth shared a bed that night, sleeping fitfully, the gun on the low table beside them. Everything seemed fine until the following morning. The young girls, examining the room one more time in tremulous

The Ghosts Through the Doorway

remembrance of the night before, still found no sign of an intruder, though both had seen the form:

> *Suddenly, Elizabeth's body was thrust through the large bedroom window. The force sent a million shards of glass blasting outward, falling onto the porch roof and the ground below. Elizabeth made a desperate grasp for the window frame and caught herself. I pulled her in even as Mrs. P. was banging at the door, demanding an explanation for the ruckus. Knowing full well that Elizabeth had been pushed, we knew we could not share that sort of information with Mrs. P. We told her something about Elizabeth having slipped, I barely remember. We were both paler than snow, all the more because Elizabeth didn't have a single scratch on her, even on her hands, which had clutched onto the frame of the window. The next few weeks were quiet, if you don't count the fact that one of the clawed feet on the tub had turned around halfway and the continual sheets of cold water that would come out of the hot water tap.*

Weeks passed in relative quiet; the window was replaced, and all seemed normal, though neither girl could forget the shadowy form that had been stealthily approaching them in their room, dimly illuminated by the streetlights outside.

Delores' peace was shattered again, more violently than the first time, after she brought home another arrangement of flowers. With the floral scent of the fading roses filling the room, Delores was sitting on the floor eating her dinner of takeout Chinese food when the floor began to buckle and undulate in waves like those on the ocean. Chinese food, flowers and the room's occupant flew in every direction. As Delores clutched the bedpost in hopes of steadying herself, the vase holding the flowers shattered in the spot where she had just been sitting, sending water, glass, stems, leaves and flower petals about pell-mell. With the flowers defiled on the floor, all resumed stillness and silence. There was no apparent damage to anything other than the floral display.

That was it for Delores. She barely spent any time in the place after that, and when she slept, she had the bravery only to catch quick batches of rest. Soon enough it would not matter; she graduated and moved into a new place and a new life. As she bid a final adieu to the home where she had had such strange events take place, she had to wonder how much of it was attached to the simple fact that the address of the home invited such associations. Shaking her head, she turned her back forever on 666 Washington Street.

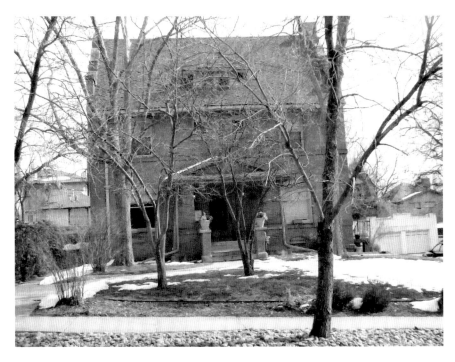

Number 666 Washington Street, in the Capitol Hill neighborhood of Denver, once lived up to its name as a ghost terrorized two of the home's residents. *Photo courtesy of Delores A.*

Not far from Delores' home of old, on the 1200 block of Race, I had the chance to interview a longtime resident of Capitol Hill named Joyce T. Even before she moved into her home, the place was already known to be haunted. Previous residents saw a young girl, perhaps about ten or twelve years of age, moving around the building. She was always fascinated with anything involving water in the house, from aquariums to the bathroom sink to glasses left on coffee tables. When Joyce bought the place, she decided to make some changes to the building's general layout. This included moving the location of the bathroom, which apparently irritated the ghost of the young girl. Even after the changes were made and tenants were living in the place, the ghost vented her anger at the change of her housing arrangements. As ever, her focus was on the water. Joyce received a number of calls from her tenants stating that the water was not working. Joyce would guide them on how to access the main valve in the basement, which would have been turned off, despite the fact that no one had been down there. Eventually, the tenants knew their way to the basement valve well enough that they didn't have to call Joyce and could undo the child's mischief themselves.

The Ghosts Through the Doorway

After a fire did some damage to the house, workers were dispatched to make repairs. Joyce fielded a number of complaints from the men concerning the girl. She was moving things, dropping things on them and just generally being a nuisance, so much so that the workers ended up refusing to enter the place after dark. Though Joyce has not seen the girl herself, others have, including her daughter. Most report the girl's presence as generally being benign, the flinging of heavy iron tools notwithstanding.

Today, Joyce has opened the doors of her home to many young people. They all live there in a communal setting, pursuing poetry, art or whatever inspires them. Owing to her being a widow, there's a rather unusual ghost that has returned to take up residence, even with the new additions: the ghost of her departed husband. Joyce said:

> *When we moved in here, we decided that there would be a room just for my husband. He could put his stuff wherever he wanted, decorate how he wanted, or not, and it would be his little sanctuary. He chose a place in the basement, and it was very much his own private domain. He could get away there, a very quiet room. When we first moved in, I told him that once our own kids were gone, I would make the place into a commune and let kids be here all the time. He responded, "Over my dead body," or something like that. "Whatever you like, dear," I replied, and pretty much forgot all about it. We lived here a long time, and I really didn't think anything about what I had said until after he had passed away. I remembered the idea and made it happen. I told one of the young men moving in that he could have that room as his own if he would clean it out; I really wasn't up to doing it myself, as you might imagine. I couldn't deal with it. The young man took care of everything, but he told me there was a ghost in the room, a presence. Knowing about the ghost of the little girl, I thought that was the ghost he was seeing. Now, my husband used to write me a poem every Valentine's Day, a romantic little tradition. One day, after he was gone, I was looking through the old poems that he had given me, just reminiscing. A short while later, when I came down into the living room, I found the kids all worked up over something. They told me that a ghostly figure had walked right through the front door, milled about a moment and then gone back again. He didn't seem to see them or hear them at all. When they described him to me, I was amazed. It was my husband! At first, I had to laugh when they described how he had not been able to see or hear them. I told them that if he had been able to see them, he would have yelled at them to get the blankity blank out of his house, since he was not a very friendly*

man to strangers. Since he was a ghost, I guess it didn't matter. Then I realized that his ghostly appearance had coincided with my reading the old poems from Valentine's Day. So I knew he was still around here, and that made me see things a little differently. When the young man living in my husband's old room moved out and another fellow moved in, he too could tell that there was someone in that room. I told him to tell the ghost that he would treat the place with respect, and he has not had any problems with my husband's ghost.

I enjoyed meeting Joyce and seeing the commune and all the lively pursuits that go on there. Meeting her, I wondered if the phrase "till death do you part" might need to be revised for some people.

Before it became a private residence, Maggie had the chance to work at the Denver Victorian Playhouse at 4201 Hooker Street, which has now changed its address to 4211, perhaps to distance itself from its theatrical past. In the late 1800s, George Swartz moved to Colorado because fresh air and sunshine were the best-known treatments for tuberculosis. There

Formerly a theater, this private residence may still hold the dramatic ghosts that once kept an artistic eye on the performers within.

The Ghosts Through the Doorway

was no cure. People tried all kinds of things to get rid of the dread disease, including living on a grated floor over a bunch of cows so that the healthy smells of the cows would waft up into their bedrooms. Mmmmm, breathe it in! Anyway, Mr. Swartz decided to read aloud to exercise his lungs and could think of no better goal to set for himself than to read aloud all of the works of William Shakespeare. His family would listen to him read, which allowed for the passage of many an enjoyable evening. Over time, other friends, neighbors and extended family would turn up to hear him read. When he began construction of his new home on Hooker Street, he placed a theater in the basement to accommodate his growing audiences. After his death in 1937, the building went through a number of uses and owners before returning to its theatrical roots in the late 1950s. One of the directors who worked there was named Paul Willett. He worked in the place for many years until his own death in 1984. He spent twenty-eight years at "the Vic," as it was affectionately known, and never left. Really. He has *never* left.

The building is very haunted. Although there is no way to compel a ghost to tell you anything, Maggie explained, some ghosts are willing enough to share their names as well as their foibles:

> *One of the ghosts in the old Denver Victorian Playhouse is Paul Willett. He has a beef with women in general and with people leaving their shoes on the dressing room table. We're quirky in the theater community, and this was one of the quirks that he kept with him even after he exited stage right. One night while we were all there rehearsing, Wade, who owned the theater at the time, was sitting in the library area and heard a series of loud bangs from above him. He made his way upward in the building, eventually reaching the attic. Since it was a theater, there were lots of costumes and other theatrical pieces stored there. He found all the shelves still in place, just empty of shoes. They had been cleanly plucked from the shelves and thrown all over the place.*

As it turned out, one of the actors had left his shoes on the dressing room table, inciting Paul to his act of footwear sabotage. Maybe Paul Willett's ghost is related to Josephine at the Aveda Spa and Salon on Market Street downtown. She has a thing about shoes, too.

The former owner of the Denver Victorian Playhouse is named Wade. When he bought the place, he did not believe in ghosts, brushing them off because anything you can't see doesn't exist. To him, it was just a neat old house with a theater in the basement. All the same, the ghosts were eager

to prove how helpful they could be in his efforts to make a successful go of the theater. After all, they had tried once before without his taking the hint. Before owning the theater, Wade had come in to do some electrical work on one of the soundboards. It was old and was having problems, but Wade gave it all he had. Many hours passed, and nothing was working. He needed the manual. The soundboard was unfamiliar to him, and without the manual he would not be able to piece together the elements necessary to make it work. He searched everywhere in the control room. Finally, in exasperation, he kicked a filing cabinet and screamed out, "!#$^@&, ghosts, I need some help!" Spent, he went for a brief walk. When he came back, the second drawer on the filing cabinet was open, and there was a naturally open place in the files. The open place contained the manual. It had not been there on his previous twelve searches through the cabinet—perhaps it was lucky number thirteen. Despite the helpful hand of a ghost showing him the manual, Wade still insisted that the building was not haunted, even when he later bought the place. Sure, he never liked the landing between the kitchen and backstage area and would race up or down it, *stomp stomp stomp*, with the hairs on the back of his neck bristling, but that didn't mean anything, Wade was convinced.

Eventually, Wade came to accept that not everyone there had shuffled off this mortal coil. There were ghosts still present, and they wanted him to make something of the theater. The combined efforts of ghost and guy alike were not quite enough, though, and the theater recently left audiences behind permanently. I hope the homeowners there are keeping their shoes off the tables.

In my first book, I already took you on a walking tour of some of the ghost-enhanced properties of Capitol Hill. I did not cover them all because, as something that is meant to be a two-hour walking tour, I have to limit my distance to those areas we may reach. I *do* talk about Cheesman Park in the book, even though we don't walk over there on the tour; it's simply too "juicy" a bit of history to leave unearthed. I now need to touch on two marvelous and historic structures that I did *not* discuss in my previous ghostly go, and those are the Grant-Humphreys Mansion, at 770 Pennsylvania Street, and the Byers-Evans House Museum, at 1310 Bannock Street. The former, in Capitol Hill, is just a little too far south to walk on the tour. The latter, located in the area known as the Golden Triangle, is a little too far west. In writing, however, we are not limited by that in any way. So we will start with the splendor that is the Grant-Humphreys Mansion, but before we do that, a little history of the mansion to set the stage. You know I love history!

The Ghosts Through the Doorway

Both the Grant-Humphreys Mansion and the Byers-Evans House Museum are owned and operated by History Colorado, the historical society that has been around and protecting the history of our lovely state since 1879.

Built in 1902 for James Benton Grant after his single term as the third governor of the state of Colorado, from 1883 to 1885, the mansion has been the home to two families and is a fine example of neoclassical architecture. Grant's greatest claim to fame is his involvement in ore smelting. He worked in Leadville and then Denver. His Grant Smelting Company, located north of the downtown core of the city, had the tallest furnace stack in the country at the time and the third largest in the world. Smelting was a huge industry in Denver. This had mixed results for Denver. On the one hand, it brought lots of jobs to the city and a lot of people to fill those jobs. On the other hand, the unregulated industry produced massive amounts of pollutants. Since Denver sits in a natural bowl (sure, it's the Mile High City, but oddly enough pretty much *all* of the suburbs are higher in elevation than Denver, which sits in the pleasant low area centered on the confluence of the South Platte River and Cherry Creek), those pollutants tended to settle right over downtown Denver and stay there. Hack hack, wheeze wheeze, teary eyes and all the rest—people found a lot of encouragement to move out of the downtown core and into the suburbs, where the air was cleaner. The high ground provided the perfect place to get above the city's earliest brown cloud and, while they were at it, try on some high morals as well. The governor's wife, Mary Goodell Grant, was prominent in Denver society and did much for the city's poor. Following James Grant's death in 1911, she remained on in the house, finally selling it to Albert E. Humphreys in 1917.

Remembered as the "Wildcatter Deluxe" or the "King of the Wildcatters," owing to his work with oil in the West, A.E. Humphreys also pursued philanthropic goals. His wife, Alice, and their two sons lived in the house. Upon the death of the elder Humphreys, the home passed to the next generation and was eventually bequeathed to the state. When the state acquired the property in 1976, the house was in a sad state of affairs, having long been neglected. Most of the great mansions of Capitol Hill had been torn down many years before, so it was quite an achievement for the Grant-Humphreys Mansion to be standing in the first place. Its future might have been uncertain, but since it was now a state property, the state began the process of repairs. Much needed to be done.

Today, the Grant-Humphreys Mansion is a resplendent gem in Denver's crown, a tribute to an area that set itself apart from the neighborhood around it by taking on a name that denoted its geographical and classy superiority:

The exquisite Grant-Humphreys Mansion, one of the jewels of Denver's Quality Hill and home to more than just history.

Quality Hill. In addition to portraits of the Grants and the Humphreyses, the house contains numerous examples of ornate woodworking and other original features. Upstairs, some of the rooms have been converted to offices, and one acts as a preparation location for the many brides who use the mansion for their weddings. I have attended a wedding there, and there are few things as superb as seeing the breathtaking bride, long white dress behind her, coming down those stairs. I was also surprised with a birthday party there, but that's another story.

Two main chambers are located in the basement. One, a ballroom, comes complete with a stage. The other is long and thin and serves as a bowling alley, though not a bowling alley as you might conceive today. The families would play ninepin, which involved small wooden pins, like miniature clubs, and a heavy wooden sphere about the size of a baseball. I bet you will be able to guess how many pins, too! Someone had to go through the labor of standing the pins up after each roll along the bowling alley floor. It's backbreaking work, and knuckle breaking too if the people throwing the ball do so with too much gusto or before your hands are out of the way.

The Ghosts Through the Doorway

Trust me…I know! Interestingly, this area was originally a firing range used by the Grants.

I have had the good fortune to spend a lot of time at the Grant-Humphreys Mansion, though not as a bride (no surprise) or groom (alas). Through my work, I conduct overnight camps on history with local school kids. They tend to be elementary or middle school kids. We head out into the city and see all the sights, exploring the shiny city for all its historical oomph. After an exhausting day (run up the hill, I will meet you there…oh wait, I have changed my mind, run back down the hill, let's talk here), the kids need a place to sleep. After all, it *is* an overnight camp. Working with the kind folks at History Colorado, I have had the good fortune to be able to use the place to house the kids overnight.

When we get to the mansion, the first question out of the kids' mouths, invariably, is whether or not the place is haunted. Once or twice I have told them yes and then spun ghoulish tales of dismemberment, vivisection, exsanguinations and defenestration, just the sort of thing to amuse me and help the kids sleep. Turns out that such stories were *not* the thing to help the kids sleep, so I stopped telling them about all that stuff on the night they were slumbering in the mansion. I decided to tell them the next morning, when the bright sunlight would drive away any fears, when they would be returning to their comfortable beds without having to worry about it.

On one occasion, though, a ghost of sorts *did* show up, and though it was scary for the participants at the time, it has made a nice story for us ever since, so I'll share it now.

After a day with the little darlings (because, you know, I think kids are just endless amounts of fun…no, seriously), I am eager to head home and sleep in my own bed. I turn the kids over to the tender mercies of their teachers and chaperones who have been with them all day and, as you would expect, a member of the staff of History Colorado. Since the building is a historic property, a member of the staff must be on duty at all times. So the staff member sleeps upstairs in one of the bedrooms that has remained a bedroom. Meanwhile, the teachers and chaperones are downstairs with the kids. The girls are in the ballroom, and the boys are in the bowling alley. After lights are turned out, the excitement of a novel location and having a sleepover with a bunch of friends leads to a lot of chatter, twittering and general monkey business. The teachers threaten, cajole, plead, et cetera, and eventually things quiet down. After all, it's been a very long and exhausting day. Eventually, all is silence and slumber.

Well, normally. On one night, however, communication channels were a little askew. One of the staff of the Grant-Humphreys Mansion, charged

with cleaning, came to the place to do his nightly work. As he came down the stairs, he was somewhat bemused to see the doors to the ballroom closed. So in one great motion, he slammed them open. With no lights to turn on (they are located in a nearby closet—weird!), he was illuminated only from behind by the stairwell lights. Moreover, the fellow in question works the night shift, so there's a bit of pallor there, too, lending to the overall impression.

Now, have any of you ever attended a sleepover with a bunch of middle school girls who think they are in a deliciously haunted mansion? The atmosphere is ripe, I tell you, *ripe* for terror. As the doors banged open with a terrific crash and the lights behind him showed a great, towering figure in the doorway, pandemonium of epic proportions ensued. If I had enough exclamation points, I would attempt to write down a verbalization of the scream. Suffice it to say that the teachers were panicked, the students were screaming and, above them, the man who had come to clean the place was almost startled out of his wits.

The staff member was roused, things were explained, middle school girls were calmed and peace ensued. To this day, however, it remains one of our favorite stories about the Grant-Humphreys Mansion: the night when a "ghost" showed up to clean. We could all get so lucky! Now that we have started you off at Grant-Humphreys with something a little lighter, it's time to delve into a more sinister set of offerings.

The true hauntings at the Grant-Humphreys Mansion were related to me by my friend—the diva of all things dramatic—Maggie. She has been charged with bringing creative theatrical content to both historic properties (Grant-Humphreys and Byers-Evans) and has done so with verve and vision, but these activities don't come without some consequences, both pleasant and otherwise. Even before she began working with History Colorado, she worked with a ghost-hunting group and had the opportunity to visit Grant-Humphreys. Between the ghost hunts and the hours on the job, she has experienced a lot.

Grant-Humphreys holds a curious dichotomy for Maggie. Splendid, ornate, very welcoming in appearance and in function, where weddings, meetings and surprise birthday parties take place, it is nevertheless home to something much more sinister beyond the perception of the average visitor:

> *We have done Shakespeare readings in the Grant-Humphreys Mansion. It's a beautiful building, but the place has a nasty energy, very repellant. Though a death happened there* [the accidental shooting death of Mr. Humphreys on the third floor of the house]*, it's not because*

> of his death that the place has issues. Two of us were in the ballroom, since we had a show coming up, and we were going over some details. We were standing on the stage and heard a very loud growl right behind us. It was very close behind, a very low, gravelly growl. I cried out, "What was that?" or something like that, and we looked around, at first thinking an animal had gotten in through the basement door, but there was nothing there. We didn't really expect to find an animal, because the feeling had supernatural menace written all over it, but we always try to look for conventional answers first.

Since Maggie was in charge of the programs being conducted there over the summer, she often had to go into Grant-Humphreys by herself. She did not like to do so, but her work required it. The basement was especially problematic for a person with as much sensitivity as she possesses. The basement gave her "the willies," and she would go down, unlock the places that were necessary to be unlocked and head upstairs as fast as she could go. Quite frequently, she would hear footsteps in other parts of the building even though she was alone. She had to look around herself to make sure no one was trespassing in the building. On the occasions when she had someone working with her, she would always take that person along for safety and reassurance:

> During our third investigation there, before I was doing theatrical work within the mansion, we were able to record a little girl's voice, speaking in French. I called her "sweetheart," told her she could come and sit on my lap. We could hear sounds on the recorder of the girl playing. Then we distinctly heard her say "I love you," in English. That was a little sad.

Ghost hunters, such as Maggie, use many tools in their work. Some of the most common are sound recording devices. When they get something on their recordings that they did not actually hear themselves, this is an EVP, an electronic voice phenomenon.

Grant-Humphreys really got hot in the summer of 2011, Maggie continued. It was not all unpleasant, at least to start, for she had become more familiar with the ghost of the little girl within the mansion:

> I would do a lot of my work in the upstairs offices, since there were not really many negative feelings there, and I started to hear the voice of the little girl again, the same voice that had told me she loved me. She began

> to be visible, gradually. A cute, blond little girl with ringlets, a sweet little pinafore dress, but I don't know who she is. She never talks about herself, so I don't know her name. I saw her with my mind and then, finally, my eyes. We got to the point where we were relaxed enough with each other to make a bit of contact. While I was working, she would come in and sit on my lap. She would play with my hair. It felt exactly the same, as if someone was sitting right there on your lap twisting a bit of your hair around her tiny finger. I could feel her weight and her heat, and I would even get hot from having her sitting there, though some people associate only cold with ghosts. It was pleasant enough, but it didn't remain so tranquil. All of the sudden she would just bolt from the room, running away, and then I would feel nauseated, a sense of dread, something looming. It made me want to run screaming from the house, but I could not, since I had work to do. The ghost of the little girl could sense it; so could I. There was something very bad in that house, and it was not ever human. I believe it was an inhuman haunt.

Over the course of her regular work at Grant-Humphreys, Maggie would become quite familiar with this particular ghost:

> *The activity at Grant-Humphreys kept getting worse* [in the summer of 2011], *and I don't have any business being the person to take on cleaning that place of its spiritual issues. I was there one night with a co-worker, and she saw Mr. Humphreys walk into the room. I turned and could feel where he was, though I could not see him myself. The sadness just pours off him, so palpable, coming in waves. I don't think he shows up that often, but when he does, he makes the people nearby sad. His appearance was not long, but we still decided to get outside for some air and a cigarette.*

Before we go too much further, I should mention that Mr. Humphreys had some associations with the Teapot Dome Scandal of the Warren Harding administration. His death, on the third floor of the mansion, was judged to have been accidental, though some disagree with that assertion.

So, Maggie and her co-worker went outside for a ciggy treat. While they were outside, they were able to peek into the building's beautiful sunroom. Wanting to get the full effect, they decided to go into the sunroom upon reentering the building:

> *When we went back inside and were walking by the landing, we heard the sound of cicadas, lots of them. It was inside the building, on the*

staircase. We stopped dead, and then the sound stopped as well. After a few moments, we began walking across the main room again, toward the sunroom. Again, the cicadas sounded behind us, a loud and insistent noise, so we stopped. Each time we moved, they sounded. Each time we stopped, they stopped, getting louder, more plaintive the closer we got to the sunroom. I knew I was being warned away from something, but sometimes I don't want to listen. The worst part was that I knew something was in the sunroom, I could feel it. All the same, I kept going, though my co-worker was hanging back by this time. I crossed one foot over the threshold, and then I saw him. It was a shadow man, the monk, sitting there. I could tell that he was guarding something, probably a portal. Although it's kind of hard to know in the conventional sense, since there's no differentiation between facial features, clothing or anything else, I could tell that he turned to look at me. Then he stood up. Behind me, the cicadas were going nuts. He began walking slowly toward me, and that is when my courage failed. I backed away and rejoined my friend.

I asked Maggie *why* there was a portal in the sunroom at the Grant-Humphreys Mansion. She explained that sometimes they open by themselves. Also, someone may choose to open them. Oftentimes, this will be paranormal research teams looking for ghosts. If they are not careful in how they go about their work, they might end up opening a portal, a point of entry between our world of time and physical laws and the world of the ghosts and everything else that awaits there. Some people open portals because they are mischievous, mean spirited or downright evil. Ghost hunting groups have opened portals at Grant-Humphreys and Byers-Evans, which has caused some problems. Maggie was able to get the one closed at Byers-Evans with the help of her friend Meghan. The one at Grant-Humphreys, however, was going to trouble her for a while, especially since the ghost was guarding it:

> *Sometimes, when we need to help a ghost move on from its location in this world, we will open a portal so that it may do so, but we always close the way when we are done. My colleagues and I don't open portals just for fun. It's not recreation; portals are serious stuff. They reflect the intentions of those who open them. If the person is good in intention, then the portal will be the same. Even when you open a portal, not all ghosts go. I could tell that this ghost in the sunroom of the Grant-Humphreys Mansion was not going to go anywhere easily.*

The following night, as she and a male colleague closed up the building after a performance, they heard a clicking sound nearby. Unsure what it was, they investigated. In her effort to re-create the sound, because that which may be re-created is not a ghost, they ended up trying a number of things. Finally, they concluded that the dangling tag on the fire extinguisher had been flicking back and forth. The sound was the same. Uncertain what would have made this sound, Maggie turned to tell her colleague:

> *Though we were in the basement, in the bowling alley, the shadowy figure from the sunroom was there, assaulting my co-worker. The ghost was choking him. I stepped into the room and told the ghost that he was not wanted there, that he had to desist, and he went back upstairs, but the message was clear to me.*

As she tried to comfort her friend, who was understandably stunned to have had something he could not see choking him, Maggie concluded that

Denver's Victorian masterpiece offers a little bit of everything. Make sure you attend one of its numerous theatrical performances or visit the gallery. Who knows? You might see a little something more!

The Ghosts Through the Doorway

Grant-Humphreys was populated by ghosts that were too aggressive and powerful for someone with her sensitivity. For those who were spiritually unaware, the place might be nothing more than a beautiful venue filled with historic possibilities. For her, however, it was turning into a scenic spot filled with ghostly mines. Perhaps we should do a roll call of the rooms: Kitchen? Check. Ballroom? Check. Dining room? Check. Hall? Check. Library? Check. Billiard room? There used to be one. Hmmm, is that a candlestick?

Although my favorite residence in all of Denver is the Waring Mansion (which we talked about in the last book and which is haunted, haunted I tell you), my favorite state property, wonderfully cared for and administered by History Colorado, is the Byers-Evans House Museum. Oliver Wendell Holmes referred to the Massachusetts state capitol building as the hub of the solar system (a bit grandiose, especially considering Boston's roads), but I understand his sentiment. If you had to choose an equivalent building for Denver, I believe many who are "in the know" would say that this exemplary building would qualify.

So let me tell you about it. Remember, I am a historian, and this *is* my favorite historic property, so prepare to "get learnt."

The Byers-Evans House was built in 1883 for William Newton Byers and his wife, Elizabeth. They had moved into the new home that was built especially for them in the new Evans Addition on the outskirts of Denver. Their previous home stood at Colfax and Sherman, so the location of their new home was close by and yet altogether new. William and Elizabeth had been among the earliest arrivals in Denver City, Kansas Territory, in 1859, when Byers beat out other competitors to print the first newspaper in the territory: the *Rocky Mountain News*. The paper closed operations just shy of its 150th birthday in 2009. Byers operated the newspaper for years and was instrumental in promoting the fortunes of Denver even in the face of tremendous adversity assaulting the young, isolated settlement. He and his family lived in numerous places around Denver before settling at 1310 Bannock in 1883. They lived in the home for only six years before moving farther out of town, to Washington and Bayaud.

During the early years in Denver, Byers had developed a close relationship with the second territorial governor, John Evans, who had come to Denver in 1862 at the request of Abraham Lincoln. President Lincoln had started in office just after the creation of Colorado Territory. Evans himself was an accomplished doctor who had, among other things, helped Lincoln get elected in Illinois and had earlier founded Northwestern University. The town was named in his honor: Evanston. During his time in office,

The Byers-Evans House Museum once held two of the city's most prominent families, with individuals who would shape almost every aspect of the city's future.

and thereafter, Evans was a constant and faithful promoter of everything Denver and Colorado. He helped change perceptions of the so-called Great American Desert and encouraged constant migration to Colorado, which wasn't too hard to do with reports of gold strikes flooding the East. Still, his efforts brought conflict with the Native Americans, and this would eventually lead to his removal from office after the Sand Creek Massacre of 1864.

Even with this tragedy, however, Evans' effect on Colorado cannot be overstated. He encouraged early agricultural efforts, secured reliable water supplies with the help of others, dabbled in real estate development and speculation and, most importantly, lent a hand to raise money to tie Denver to Cheyenne via an important railroad link. The railroad had bypassed Denver for the easier route through southern Wyoming. Evans and other business leaders, through the new Denver Board of Trade (it having been founded by Byers and others), raised enough capital to build this important spur—a spur that ended in Denver and not Golden. Evans knew that this link would open the floodgates to a population boom, and he was right. It is therefore not surprising that his new subdivision was located on the

outskirts of the southeast quadrant of the original square mile that made up "old" Denver. Before Evans passed away in 1897, he had also founded the University of Denver in 1864 and watched the city blossom from a population of about 4,700 in 1870 to nearly 110,000 in 1890. Denver was by that point the twenty-fifth-largest city in the nation. He also continued to be a huge railroad promoter and was instrumental in helping develop the city's massive streetcar network through his time and investments. To honor his time in Colorado, citizens renamed the mountain west of Denver as Mount Evans.

John Evans' earlier house stood downtown at Fourteenth and Arapahoe. By 1883, that was in the middle of a growing business district. Fashionable folks were leaving the city for the suburbs, and the new Evans Addition was just such a place. So it was not unexpected that Byers should purchase a lot in his friend's new subdivision and have a large Italianate home built on the site. What is more interesting is that when it was sold in 1889, John Evans' oldest child, William, was the purchaser. William Evans had traveled across the prairie with his mother, Margaret, and father in 1862 to the dusty town of Denver City. He had grown up in the town and was quickly becoming one of its prominent citizens. He had married Cornelia Gray, and they had four children: John, Josephine, Margaret and Katharine. He and his family would then begin a legacy of habitation in the home that would last until 1981.

William Evans became president of the Denver Tramway Company, one of a number of streetcar systems in the city by the late nineteenth century. Eventually, Evans would have a monopoly on a consolidated system and would oversee its expansion to most areas of the city. He built the Denver Tramway headquarters building on the site of his father's old house at Fourteenth and Arapahoe—a building you can still see today in the form of the Hotel Teatro. He also oversaw the expansion of his home at 1310 Bannock. After his father passed away, William welcomed his sister, Anne, and his mother, Margaret, into the home. He even had a new wing built on the home to accommodate everyone and house many of his father's belongings. This added greatly to the size of the place. William's mother passed away in 1906, and he passed away in 1924. His sister resided in the house until her death in 1941. William's wife, Cornelia, lived well into her nineties and passed away in 1955.

The children were raised in the home and watched the house and neighborhood change around them. Son John eventually moved out and married Gladys Cheesman, daughter of water baron Walter Scott Cheesman. For a time, they lived in the Cheesman Mansion at Eighth and Logan, which

is now the current Governor's Mansion. John and his sister Margaret would eventually be the ones who donated the house to the State of Colorado to save it from being lost to history. Margaret married pharmacist Roblin Davis, but he died many years before she did. She would later move back in with her sisters, who lived their whole lives at the house on Bannock. Josephine had been a Red Cross volunteer during World War I and never married. Young Katharine also never married. Josephine died in 1969, Katherine in 1977, John in 1978 and Margaret in 1981.

The neighborhood changed greatly over that time. By 1980, what had once been a residential area had turned into a sea of parking lots for downtown. The neighboring Grace Methodist Church, which sat catty-corner from the home, was demolished by the University of Denver to make way for a parking lot in 1959. A small chapel that sat adjacent to the church had been constructed by Governor Evans in 1878 to honor his daughter, who was also named Josephine. She had succumbed to tuberculosis. The chapel was saved and moved to the campus of the University of Denver, where it stands today.

The house itself, though, changed very little from the Evanses' time. When the state received the property in 1981, it was decided that a full restoration of the home would be undertaken. The building is now one of the best-preserved house museums in the nation, restored to the 1912 to 1924 time period. The Evans descendants decided to donate not only the house but also all of its contents. This important distinction makes the home even more special. When a person walks through the house, he or she is seeing the house as it would have looked during that time period (although the parlor dates to the Byers era in the home, circa 1885). This includes the great library area, which contains many belongings that came over from Governor Evans' home at Fourteenth and Arapahoe, including the chandeliers, bookcases and furniture.

Upstairs, one finds Anne Evans' room and sitting area, full of her belongings. Anne was instrumental in helping to found the Denver Art Museum. It began its life as the Denver Artist's Club in the 1890s, of which Anne was a member. She would go on to help spur the Denver Public Library's growth, including advising on the construction of its first permanent building in 1910. She aided in the beautification of Denver's City Park and Civic Center Park, as well as saving the Central City Opera House. She was also a huge proponent of Native American art, promoting basketry, weaving and pottery as art forms. Her collection of southwestern Santos and other art pieces was donated to the Denver Art Museum upon her death.

The Ghosts Through the Doorway

When the Denver Art Museum was looking to expand its building in the late 1960s, it bought up the rest of the beautiful homes on Bannock Street but left the Evans home untouched. It could hardly condemn the Evans house to demolition, especially when its founder's nieces were still residing in the home. When Margaret Evans did pass away, it is interesting to note that the home was donated to the State of Colorado, and *not* to the Denver Art Museum, for preservation in perpetuity. Perhaps the family feared that a parking lot was in its future otherwise.

The home is full of stories and objects and perhaps the remnant ghosts of this prominent Denver family of pioneers and their descendants. Volunteers and staff who get the chance to be part of this beautiful home have reported a warm presence in the house. Could it be Anne Evans? In the upstairs master bedroom of William and Cornelia, staff members have reported being touched on the shoulder at different times, always when pulling the shades closed in the room. Staff members feel that it is Cornelia, William's wife, trying to get their attention. The home has had numerous visitors over its many years. It also had many servants who lived in the home, helping the Evanses and adding to its mystique and charm.

This restored home is a window into our past, one of the few in Denver from this time period and one of even fewer left in this once residential neighborhood. The home is now surrounded by museums and other civic buildings. The yard is a green oasis of trees and grass among the urban fabric. One can still see Cornelia Evans' yellow rosebush blooming in the northwest corner of the yard. If one had told William Byers or William Evans that their home would be the only one left standing one hundred years hence, I'm sure they would have laughed in disbelief. And yet, there it is. Alone, yet shining, with the Denver Art Museum literally built on the property line and jutting upward. If the home were gone, would the ghosts remain? Are ghosts attached only to houses they know, and do they disappear along with the building? Once their stories are lost, do ghosts disappear too? All of the other homes that once graced today's Civic Center Park or the lots adjacent to the Byers-Evans House Museum are mere memories on photographs, but this home today allows us the chance to capture that past and have a window into a vague chapter of our city's early years. If you have not visited, you should. In walking through the doorway, you are entering the majesty of a lost world.

Though Byers-Evans is full of nicely solid representations of the Victorian world, it also has a full cadre of offerings that are not so solid. Yep, Byers-Evans is haunted. Maggie (remember her?) did not give me a walking tour

so much as a tour of the walls, stairwells, landings, rooms and secrets as she has seen them with her own eyes:

> *When I started working at Byers-Evans in 2005, I was still scared of my awareness of ghosts and didn't want to be in the house alone. I'd already been there to see the Edgar Allan Poe readings, the year before I took those over, and after I picked up my ticket, I happened to be the first one to walk into the library, where the performance would take place. As I did so, the big lead glass door on the bookcase swung open. That scared me, I tell you. Now that I have worked there, I have examined that bookcase. That door is heavy and doesn't just move accidentally, no matter how much we're tromping through there or moving chairs for a performance. In recent years, I noted that a first-edition book by Poe is in that bookcase. I didn't know that at the time. I just knew I was scared. That was my first encounter there, and the interactions have just gotten more intense. When I took over the performances of Poe's works for Halloween, the first place I visited was the library. "I know you're here, and you know I am here. I am not going to do anything that is going to hurt you. Please respect me, and I will do the same." The ghosts who were here then, well, they listened. Unfortunately, things have not remained the same.*

The second thing that happened to Maggie in Byers-Evans took place in what was the carriage house. Though it would have once smelled of various horse contributions, axle grease and hay, today it is the reception room for the museum, where guests pay for their entry and check out art and educational displays that illustrate some aspect of the building, city or state's history. The room is very modern, not at all Victorian, and sterile so as not to draw attention away from the art and gift offerings:

> *We were in there rehearsing "The Black Cat," a marvelous work by Edgar Allan Poe. As we got to the line "and here, through the mere frenzy of bravado, I rapped heavily, with a cane which I held in my hand," we heard a steady, distinct sound, as if something was rolling along the wooden floor on the level above us. We felt some alarm at that because there is no level above us there. Still, the sound was unmistakable.*

Moving on to another piece for a bit, Maggie filed the incident away in her mind for the moment. A few days later, she had the chance to converse with a colleague who had performed in the Poe readings before, though she was not a part of the troupe that season:

The Ghosts Through the Doorway

When I told her what had happened, she just blanched. She asked me again what lines we had been on when the sound had stopped us. Feeling a touch of trepidation, I answered. She blinked a few times then told me, "Maggie, the exact same thing happened to us when we were practicing in there one night, on the exact same lines." The only difference, she told me, was that after they had heard the sound, she had sent people into the upper levels of the house to see if anything was amiss, whereas I was too scared to do so. Nothing. They found nothing.

Maggie has done a number of different performances, not just the chilling works of Poe. During another theatrical engagement called *Letters Home*, Maggie and her colleagues were working in the education room (which used to be a bedroom, first used by William's mother, Margaret). She and her colleagues distinctly heard furniture being dragged somewhere on the upper floor. In this case, wondering what was going on in the rooms of the second level, Maggie sent two of the actors upstairs to look for the source of the disturbance. Though they found nothing moved or out of place in any way, the lady in this duo, also a three, had the distinct feeling that the ghosts were toying with them, playing hide-and-seek, entertaining themselves at the actors' expense.

The second year that Maggie and her colleagues produced *Letters Home*, she was sitting in the library with her assistant director and the actors. They had, so that Maggie could review it later, a voice recorder operating. Things were not going along as quickly as Maggie was hoping for that evening, so at one point she stated that they were running out of time and should skip ahead to a part of the play that had been giving them greater issues. The assistant director agreed; there was a pause as everyone shifted to the correct place in the script, and the rehearsal continued.

Later, when Maggie was listening to the recording that they had made, she noticed a voice that did not belong to anyone chiming in at a time when no one had been saying anything. There was a distinct voice right as the folks were busily shuffling pages to get to the new part of the scene. In perfect clarity, a woman's voice said, "I peeked at Mrs. Esther." It scared her:

At that time, I did not really know anything about the history of the house. I knew there had been some folks called Byers and some other folks called Evans, but that was about it. I was just there to do theater. After hearing the recording, which was certainly no one in our group, I took the recording to speak with a staff member. When I played it for him, he went very pale.

> *He explained to me that Esther Allspach was the head servant in the house at one time.*

This was not the only time that her recordings of their rehearsals yielded voices that did not belong to the corporeal. Agonized screams, epithets of mayhem and murder—many of the voices she heard experienced torture without reprieve. Others quietly lamented their woes.

On another occasion, the house virtually burst forth with ghosts making noise. While rehearsing, again in the library, they heard things being dragged around upstairs. In the music room, they heard the antique record player sounding its old and tinny tune. Clocks chimed away from the quarter, half and full hour. Maggie and her colleagues called it a day.

There were also occasions when the spectral interactions left behind the realm of the auditory and entered the physical:

> *We were rehearsing in the library* [the main performance venue in Byers-Evans], *working on the blocking. Many of the plays have very specific needs for where a person should be to make a particular line work. We were experiencing some frustration over a set of lines, moving around the library, when I heard a heavy THUMP THUMP THUMP. My first inclination was that someone was breaking into the house. I stood up to look around, not seeing anything in particular, but then I noticed that all the blood had drained from the face of one of my cast members. "Maggie, did you see that?" Again, my first inclination was that there was someone trying to break in, so I thought she had seen the person, and I said something to that effect. "No, Maggie. It was the clock."*

Everyone who had been facing in that direction had seen it. The grandfather clock in the foyer had pulled out from the wall and slammed back against it several times. The clock, large and heavy, was not one that anyone could have moved at all readily, yet it had leapt out and back several times. Members of the staff who examined the area, finding the plaster cracked and other signs of a noticeable disturbance, could accept it moving perhaps once but not back and forth a number of inches, several times in a row. The motion had been intentional and controlled. One staff member described the results as "creepy."

At one point, after a brief hiatus from Byers-Evans, Maggie was dismayed to find that someone had opened a portal within the house:

The Ghosts Through the Doorway

> *I was angry about that! People were messing with stuff that they did not understand. Before, Byers-Evans had a very welcoming feeling. Coming back, the tone of the place was "WHY ARE YOU IN MY HOUSE?" Underneath that, there is some fear. Someone had opened a portal there, perhaps a guest coming through the museum. With the portal open, someone had decided to come through and stay.*

Furniture would move in front of her, cold spots filled the house and the happier spirits that had once populated the place's many rooms were drowned out by obstreperous voices:

> *On occasion, we split up in the house to work on particular scenes, getting away from each other so that we are able to concentrate and work without hearing the lines and interactions of the others. I have never liked the servants' stairs. Shadows have raced up those stairs at people before, and the sensations are very close for people who are sensitive. All the same, I use those stairs sometimes, just to get around more quickly. One of my co-workers and I headed up the servants' stairs. As we reached the top of the staircase, we looked into the servants' room, which is a room I have never liked either. There, floating, looming over the bed, was a woman. She looked over at us, glaring. She was angry, repeating the same words over and over in a low, sinister hiss: "Get out of the room, get out of the room."*

Though afraid, Maggie could tell that the ghost was caught in her own place of terror because violence had been done to her during her lifetime. Maggie steeled herself to help, though her emotions were wailing against any further interaction, and she told the menacing lady ghost that she would help her find release from her entrapment:

> *The insane fear and anger I felt from her just melted away, to be replaced by sorrow. The room went from this red rage to desire almost to be hugged. After the rehearsal was over, Meghan joined me in the house and walked around with me as I locked up and turned off the lights. Everything has to be left just so because it's a historic property, and we need to maintain it for future generations. When we got to the second floor, Meghan stepped into the servants' quarters. The ghost within the room could tell that Meghan was there to help her. She approached Meghan and took her hand. We led her outside, where Meghan opened a portal and helped her depart.*

Unfortunately, Maggie's efforts on behalf of the ghost had not gone unnoticed. Though the ghost in the bedroom had merely been one trapped in a morass of confusion, anger and sadness, there were other ghosts present that had no intention of leaving, at least not easily:

> *A colleague, Amy, and I were heading through the kitchen to the gallery. The waffle iron on the stove popped open and then slammed shut. I thought that it might have done that in response to my tromping by, or something like that, so I walked back and forth again a few times, seeing what would happen. Nothing, not a hint of movement from it. Knowing the place was haunted, and having had ghosts play with us there many times before, I initially chalked it up to that, so Amy and I continued walking from the kitchen toward the gift shop and gallery part of the mansion. As you walk from the kitchen into the actual gift shop, there are some stairs going down. Just a few stairs, so it's not a big drop. All the same, as I reached the top of the stairs, I was violently shoved from behind and went falling forward, straight into the gift shop. If I had fallen the whole way, with that much force and from that little bit of extra height, I would probably have really hurt myself, but someone caught me and lowered me down. I could feel the person grasp me under my armpits, lowering me quickly to the ground.*

She looked at Amy, still standing on the landing above her. Amy's eyes were almost comically large. Maggie might have found the look on her friend's face funny had she not had such a fast and furious interaction with two different ghosts: one who intended her harm and one who intended to help her. Though this was the most severe of the incidents that afflicted Maggie, the altercations were coming more and more frequently: "The recent arrival, the mean-spirited ghost who I sense there now, also pushed one of my other actors, actually knocked the poor guy to his knees."

So she called Meghan again and asked her to sit in on a rehearsal:

> *The other actors didn't necessarily know why Meghan was there. I just told them she was a friend, sitting in to observe how we worked, that sort of thing. As Meghan listened and watched, she was also getting a feel for the place and where the ghosts were drawing their energy from within the house. There were definitely some hot spots. She was trying to clean the place as surreptitiously as possible, help those ghosts who wanted to leave. Finally, during a break, Meghan and I sat down away from the others to talk and*

The Ghosts Through the Doorway

this guy just shows up out of nowhere. Without facial hair, wearing a very fine and dark three-piece suit and a bowler hat, he's leering at us in utter loathing. He spits out, "Nobody does magic in this house but me!"

This is a true ghost, a sapient haunt, someone who once lived and had moved into the Byers-Evans House since someone opened a portal there: "This guy continued to rant. 'Get out of my house. I *will* hurt you. Who are you to come in here?'"

Maggie, who had by this time seen pictures of the people associated with the house's history, did not recognize him. Though uncertain who he was, he was likely not originally associated with the home and its families. As far as Maggie knows, the fellow is still there.

With all I have said about the ghosts at the Byers-Evans House Museum and the Grant-Humphreys Mansion, I want to leave these properties behind now with these closing thoughts for you, my erudite reader: the presence of ghosts in these places does not diminish the value of these properties in any way. They remain treasures, belonging to all of us who call Colorado home. They offer tours and theatrical events and serve as venues for weddings and much, much more. They are the workplaces for some of the finest people you will ever know. These magnificent buildings are repositories of some of the state's most essential history, so have a look!

So we end now with a woman named Dona M., whose experiences demonstrate the durability of ghosts and, in many ways, their humanity. Dona lives at 1566 Adams, near the Bluebird Theater (a nice place on Colfax, a street that *Playboy* magazine—which I read for the articles, of course—once called a very long and wicked street indeed). The house was built in the early part of the 1900s, and she moved into it in the early 1980s. As a young single woman in her first house, she was understandably excited. It was a good year for her because she also started dating the fellow who would end up becoming her husband. Unfortunately, the house that she bought had come with more than just windows and floors and such. It had also come with a ghost. The ghost got used to the idea of having a young and single lady around in his home and, apparently, rather liked it. The ghost could handle the fact that she had a dog and a cat; those were no threat to him. The ghost *did* take umbrage to her bringing another man into the place, even if the man turned out to be fleshier than he was. Since Dona did not know her place was ghost-enhanced, she was unaware of the potential issue until it had already begun:

The ghost haunting this home on Adams is kept away with a little feng shui.

As soon as I started dating my current husband, the ghost made himself known. He had not shown himself at all until my future husband came along. So, my house had one dog, one cat and one dead man. He would move the furniture, swing the blinds in the windows. It all started out quite passive, but over time he just got more and more intrusive.

The ghost would pound on the inside doors of the house, crash things around in the basement and throw things at her when she was in the shower. You would think this would be very annoying, if not downright alarming. It was all that for Dona, but she's a strong lady, so she bore it stoically enough. With her marriage, though, things got all the more interactive. The ghost would steal things and throw things at others who came into the house as well. It was usually the husband's items that would be stolen:

We were pretty sure the ghost did not like my husband being there. Since my husband is a writer, the ghost would take things he was working on and move them so that my husband could not find them. Papers, pictures,

> *whatever it might be, he'd set them down and then come back for them and find they were not there. My husband would say that he wanted them back, and the objects would appear the next day. Not the end of the world, but it caused some frustration and delays. The ghost would even take my husband's favorite clothing, which my husband thought I was doing. "No, honey, I did not throw away that dreadful, hideous sweater you like so much. I am sure it's here somewhere." Even the terrible clothes would be back soon enough, folded neatly in the middle of the room.*

I'll say this for the ghost: if you have to be haunted by a jealous ghost, you could do worse than to be haunted by one who obediently returns all your objects and even folds the clothing before returning it. All the same, things were going to get a little weirder in Dona's little abode:

> *My husband used to travel a lot for work, sometimes being gone for months at a time. Those were lonely times, since it's hard not to have your spouse around, but his work required it. Things would quiet down, but I guess the ghost was used to showing himself now so got bolder in other ways. You know how it is when you feel someone sit down on the bed? That would happen, I would feel it move, even though no one was sitting on the bed with me. That was bad, and then it started to get a little freakier. At one point, while I was lying on the bed, I actually saw a white, amorphous mass descending on me from above, lowering onto me while I was in my bed. Though it was not humanoid in shape at all, I knew it was the ghost. That really scared me a lot.*

So, in order to prevent this sort of thing from happening again, she had the house smudged, which is a Native American ritual of cleansing and protection. This helped for a little while:

> *Still, when the ghost was coming back, I could always tell, or I should say that the dog could always tell. The dog would stare into space and just growl. The ghost was there, and the dog could see him, and he would just stare. If I happened to be throwing the dog's toys, and they landed near where the ghost was, the dog would not go over there at all. The cat didn't like him either but basically ignored the ghost.*

Clever cat.

One day, while she was watching television, Dona came upon a program talking about a house in the Capitol Hill area that was besieged by ghosts.

The house was for sale, and the realtor who was talking said that the ghosts had been making their wishes known about who would take up residency in the house and who would *not* reside in the house. The realtor explained that they had had to find the portals within the house in order to control the ghosts. In controlling the portals in the house that the ghosts were coming through, one could control the ghosts themselves. Intrigued, Dona got some more information. The answer ended up almost being feng shui in nature: she had always kept her bed along either the north or south wall of her bedroom because of the location of the heating units. In order to control the portals and disallow any access on the part of the ghost, Dona learned that she needed to have her bed on the east or west wall. So she tried it out, moving her bed accordingly. Not only did she enjoy a different take on the ceiling when she first woke up in the morning, but she also had a ghost-free existence within her home. Delighted, Dona made certain that her bed was always in just the right place to keep the portal closed against the unwanted jealousies of a possessive ghost.

Life went on for many years, and she was happy without the ghost around to harass her. Its attentions had gotten far too intrusive for her comfort. Eventually, her husband's frequent travels were done, and everything looked bright for the family.

Unfortunately, there would be one more reminder that ghostly love (or is it ghostly stalking?) can be truly eternal:

> *We had had some water damage in the house and had to have the bedroom cleaned, all the wallpaper taken down and everything fixed. We didn't have our actual bedroom for three months during the repair work. One day, when I came home from work, I was happy to note that the various rooms were done and that the workers had put furniture back. It had been so long, I didn't catch the fact that they had put the bed in the bedroom, yes, but on the wrong wall. I went into the back of the house to put some laundry in, and I heard, from the main body of the house, a clear, male voice call out. "Honey, I'm home!" I was a little puzzled because I was not expecting my husband back from work just yet, but then the dog went racing past me, terrified, out into the backyard. Why would the dog do that if my husband had come home?*

With a stab of sickening dread, Dona realized that the voice she had heard was not her husband at all but a triumphantly returning ghost. It was the first time she had ever heard him speak. She immediately raced for the

bedroom. She didn't see anything as she moved through the house, but she knew the ghost was there. She quickly moved the bed across the room all by herself, placing it on an appropriate wall, and the ghost has been gone ever since. That was the late 1990s. Since then, she has received no attentions from her paranormal paramour.

So, with the amorous intentions of the not-so-dearly departed fresh in our memories, it is time to conclude this trip and bring you back to here and now.

The journey of writing this book has been a difficult one for me, partially owing to my own intense fear of all things that go bump in the night and partially because of the change in my family since my first haunted book came out about a year ago. Yet for all that, the exploration has offered me some succor, too. I have always drawn comfort from history, since it is a

Another home on the 1500 block of Adams yielded a surprise when recent residents were clearing out the garage. Apparently, it's cheaper to buy more than one headstone at a time, so the family did. When it turned out that Mrs. Leger was to be buried in Nebraska, the family was left with a headstone and no one to place beneath it, so they cemented it into the floor of the garage. Later buried by a mountain of garbage in a decaying garage, today's owners were in for a shock. They were able to confirm with the city that no one is beneath, but it's an important lesson for all of us: when it comes to life and death, the world is full of surprises!

connection to those who have come before. It reminds us that we are not alone, either in our joys or our tribulations. It binds us together with a greater whole. With history behind me, I am not quite so puny. Additionally, in discussing the world of possibilities and beliefs espoused by the many people I interviewed, there was consolation. Whether heaven, rebirth or something in between, there has been solace. As I come to the conclusion of my second book, I find myself looking forward to the possibilities of the next haunted book I undertake. What places I will go, and what tales I will know! I remain the accidental ghost hunter and ever will be, I suspect. Still, as the sun sets outside while I am typing this and the crepuscular time begins, I understand a little more that there is no need to fear the coming night.

Bibliography

Arps, Louisa Ward. *Denver in Slices: A Historical Guide to the City*. Athens: Swallow Press/Ohio University Press, 1959.
Bettmann, Otto L. *The Good Old Days: They Were Terrible!* New York: Random House, 1974.
Bradley, Dorothy Bomar, and Robert A. Bradley. *Psychic Phenomena*. Mira Loma, CA: Parker Publishing Co., Inc., 1977.
Littleton Museum: History, Art, Culture. Littleton, CO: City of Littleton, 2009.
Noel, Thomas Jacob. *Mile High City: An Illustrated History of Denver*. Denver, CO: Heritage Media Corporation, 1997.
Smith, Elaine Colvin, and Jean Walton Walsh. *The Grande Dame of Quality Hill*. Denver: Volunteers of the Colorado Historical Society, 1991.
———. *Victoria of Civic Center*. Denver: Volunteers of the Colorado Historical Society, 1984.
Snow, Shawn M. *Denver's City Park and Whittier Neighborhoods*. Charleston, SC: Arcadia Publishing, 2009.
Westminster Historical Society. *72nd Avenue, 73rd Avenue, 76th Avenue and Homes on the Off Streets*. Westminster, CO: Publishing House, 2010.
Westminster Historical Society and the Westminster Public Library. *Lowell Boulevard*. Westminster, CO, 2000.
———. *A Walk Through Westminster History: Bradburn Boulevard*. Westminster, CO: Publishing House, 1997.

About the Author

Kevin Pharris is a military brat who got off the train in Denver and has since made it his home. Pharris is a guide at and owner of Denver History Tours. Despite being someone who does not like scary things, he has become Denver's own accidental ghost hunter. Kevin is willing to go to any length to get to the truth when it comes to ghosts, even if it means losing his…

Photo courtesy of nunkizoo.

Visit us at
www.historypress.net